IMAGES
of America

SNOQUALMIE PASS

Joel —
I can't wait
for our weekend
together! Here's to
many more years
of enjoying the
snow together.
Love,
Ann

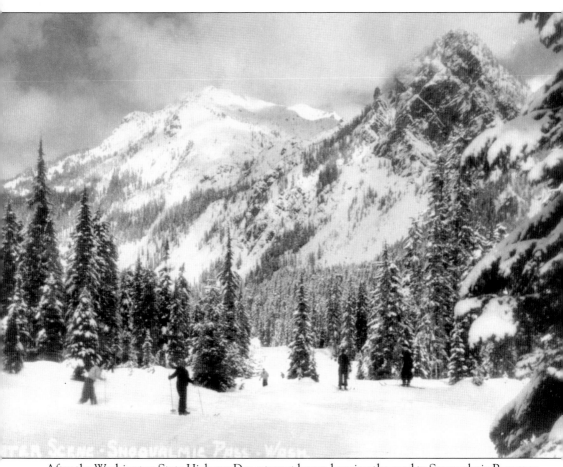

After the Washington State Highway Department began keeping the road to Snoqualmie Pass open all winter, skiing at "the Pass" became an increasingly popular sport. Skiers enjoy a backdrop of Mount Snoqualmie and Guye Peak at the summit in the 1930s. (Courtesy MOHAI, 2002.48.1099.)

ON THE COVER: Seattle-area women line up in anticipation of a day's skiing at Snoqualmie Ski Bowl in 1939. In the 1930s, women often had to sew skiwear for their families. A variety of clothing was worn; note the woman near the center of the photograph donning a skirt. Ski pants consisted mostly of heavy woolen gabardine and were often paired with fancy, patterned stockings. Hand-knit sweaters were warm and popular, and a variety of headgear adorned the ladies' permed locks or pigtails, including headbands, turbans, scarves, bonnets, and even caps. (Courtesy MOHAI, Seattle PI-26875.)

IMAGES
of America

SNOQUALMIE PASS

John and Chery Kinnick

ARCADIA
PUBLISHING

Published by Arcadia Publishing
Charleston SC, Chicago IL, Portsmouth NH, San Francisco CA

Printed in the United States of America

Library of Congress Catalog Card Number: 2007903140

For all general information contact Arcadia Publishing at:
Telephone 843-853-2070
Fax 843-853-0044
E-mail sales@arcadiapublishing.com
For customer service and orders:
Toll-Free 1-888-313-2665

Visit us on the Internet at www.arcadiapublishing.com

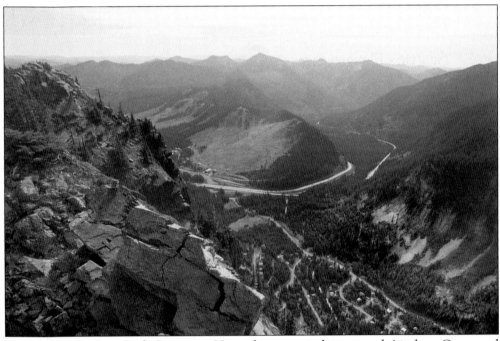

From high atop Guye Peak, Interstate 90 can be seen winding around Airplane Curve and descending into the Cascade Mountains toward North Bend. Airplane Curve acquired its name due to the many unfortunate pilots who have assumed, in poor visibility, that the highway (and flight path) continued on a straightaway rather than making a sharp turn west of the summit. The remains of crashed airplanes are still discovered around Snoqualmie Pass. At the foot of Guye Peak is the Alpental residential neighborhood with its numerous chalets and culs-de-sac. Visible above the nearby rock outcropping are the slopes of Summit West and Summit Central ski areas, with Summit East (Hyak) beyond. (Courtesy Danny Miller.)

CONTENTS

ACKNOWLEDGMENTS

We are grateful to the residents, business owners, artists, collectors, sports enthusiasts, and organizations affiliated with Snoqualmie Pass for allowing photographs, creations, and memorabilia to be added to this book of historical images.

We wish to thank Julie Albright, our editor at Arcadia Publishing, for her assistance and enthusiastic encouragement on this project.

We owe much gratitude to David Moffett, who trusted us with private albums belonging to his family that contain over 30 years of ski resort history at the pass. Our appreciation also extends to Hugh, Dollie, and Deb Armstrong, who related information about their family's long association with the sport of skiing and the story behind Deb's 1984 Olympic gold medal. We are indebted to Steven Carkeek and Richard Carkeek, who shared hundreds of unique photographs taken by their grandfather Arthur Penryn Carkeek, an early member of the Seattle Mountaineers. It was also an honor to have the gracious assistance of Joy Lucas, whose personal knowledge of the early days at the Snoqualmie/Milwaukee Ski Bowl would tempt any historian.

Sincere appreciation is owed to Danny Miller of Alpental, Jack Leeper, and Adi and Eva Hienzsch, who went out of their way to provide photographs and memorabilia. We also wish to thank Pass residents Ed and Barbara Quirie, DeAnna Reynolds and Steve White, and David and Susan Black and contributors John Mohan, Jack Price, Bob and Lois Baxter, Linda Lee Foster, Thomas Tilton, Rich Poelker, Linda Schrott, and Hank and Kit Cramer.

The Mountains to Sound Greenway Trust (www.mtsgreenway.org) and the Outdoors for All Foundation (skiforall.org) granted permission for the inclusion of photographs representing their respective organizations. The following collections must also be acknowledged for providing indispensable images: University of Washington Libraries, Special Collections; the Museum of History and Industry, Seattle (MOHAI); the Washington State Archives; and the Ellensburg Public Library.

INTRODUCTION

To many people, Snoqualmie Pass is synonymous with snow sports or hiking and backpacking. This collection of images will show Snoqualmie Pass as a community with a unique history in addition to its status as a popular recreational area. Although the Pacific Northwest is young compared to the rest of the nation, there is a wealth of stories to be told about this nook within the Cascade Mountains. Over time, the trails, roads, and waterways of Snoqualmie Pass have been touched by indigenous tribes, explorers, ranchers, pioneers, loggers, prospectors, photographers, surveyors, builders, railroad personnel, mountaineers, sports enthusiasts, and nature lovers, to name a few. As a pivotal Cascades community, Snoqualmie Pass has served as the purveyor of some big dreams, including the development of the local snow sports industry, but also of smaller, meaningful ones, like the fulfillment of a desire to live where nature can be enjoyed firsthand, with easy access to favorite winter and summer pastimes.

The first chapter, "Crossing the Cascades," reveals the role of Snoqualmie Pass in connecting the two halves of Washington State. The initial trails, made by tribes in search of food or trade with each other, changed quickly with the onset of the Industrial Age. Travel and commerce through the Pass progressed from foot traffic to horseback and wagon and finally to motor vehicles. The second chapter, "Seattle's Playground," records the development of the ski industry at the Pass in direct correlation with improved road access from surrounding metropolitan areas. "A Mountaineer and His Cabin," chapter three, consists of previously undisclosed photographs taken by Arthur Penryn Carkeek from 1910 through the 1940s. Carkeek was a mountaineer who built a cabin along the South Fork Snoqualmie River in Alpental Valley. His story parallels that of others whose appreciation for the exhilarating beauty and challenge of the Cascade Mountains has become a lifelong love affair.

One of the best-remembered figures at Snoqualmie Pass is ski resort owner Webb Moffett. "Webb's World," chapter four, chronicles the development of the local ski areas under Moffett's management. And since every community needs a hero, "The Golden Girl," chapter five, recounts the excitement generated at Snoqualmie Pass when local racer Deb Armstrong came home with a gold medal from the 1984 Winter Olympics. The final chapter, "Around the Pass," deals with the people, events, art, architecture, and unique way of life within the Pass community.

Snoqualmie Pass is an unincorporated area with both part-time and full-time residents, plus many seasonal workers and visitors. Each neighborhood at the Pass has its own flavor: Alpental (King County) and Village at the Summit, Conifer Estates, Yellowstone Road, and Hyak Estates (all Kittitas County). Yet the general feeling is that of a single community, not because of a shared zip code, but because of shared life experiences. Commutes to and from the Pass can be long and hard, especially during the winter season when highway travel can be disrupted by avalanche control or hazardous conditions—even deadly rockslides. Residents and employees must also travel many miles for certain services or cultural amenities. The people who live at Snoqualmie Pass tend to measure their residency (or resilience) in winters, not years—much like pioneers—and they would not have it any other way.

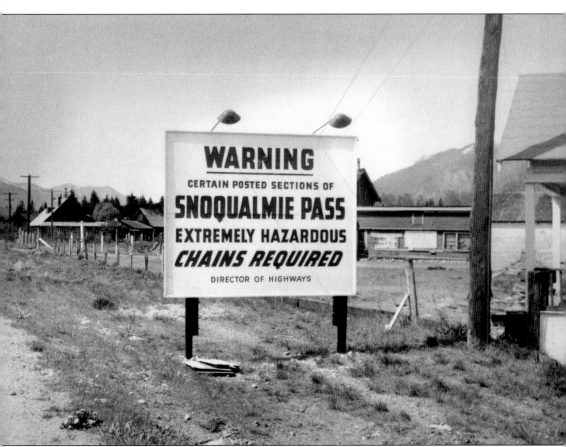

In 1947, a warning sign for Snoqualmie Pass alerts drivers to potentially hazardous road conditions. The sign reads, "Warning—Certain Posted Sections of Snoqualmie Pass Extremely Hazardous—Chains Required—Director of Highways." Current travelers across the Pass on Interstate 90 know full well that little has changed after 60 years. (Courtesy MOHAI, Seattle PI-25291.)

One

CROSSING
THE CASCADES

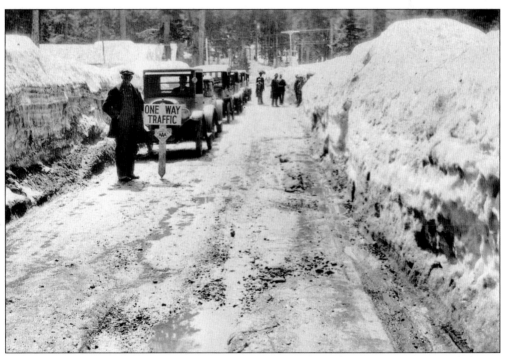

Travel across Snoqualmie Pass has always been unpredictable, with its mountain terrain and over-3,000-foot elevation. In this 1920 photograph, vehicles wait their turn to proceed up the Sunset Highway to the summit. Early travelers across the Pass were a hardy bunch, since automobiles were not insulated and offered little protection from the winter cold. (Courtesy University of Washington Libraries, Special Collections, UW23118.)

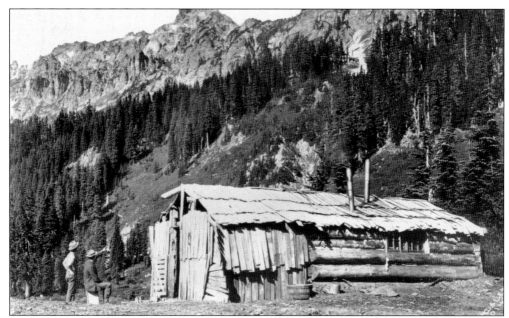

The Denny family, one of Seattle's early founders, kept this cabin at Ptarmigan Park in the Gold Creek area, about eight miles northeast of Lake Keechelus. It served as a home base for Esther Mines workers. "Uncle Will" and "McMullen" are at the front of the cabin, watching for mountain goats on Rocky Boy Peak in 1899. (Courtesy University of Washington Libraries, Special Collections, UW26881.)

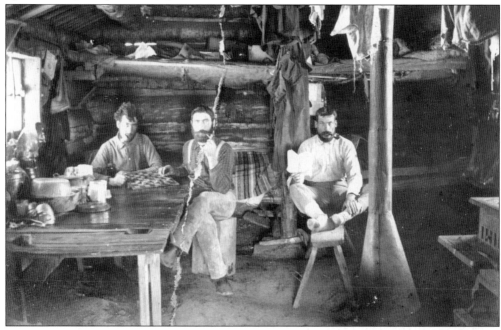

From left to right, Roy Denny, Charles Rinn, and Tom Record relax inside the Esther Mines cabin about 1907. Denny, the camp cook, plays a game of checkers with Rinn while Record balances on a narrow bench and reads from a book. (Courtesy University of Washington Libraries, Special Collections, UW26882.)

Victor Denny holds a watch and candle inside Tunnel B of the Esther Mines in 1901. While Lawrence Lindsley took the photograph, Denny timed the exposure at three minutes. Lindsley worked in the mine for seven summers and helped drive about 250 feet through the tunnel. (Courtesy University of Washington Libraries, Special Collections, UW26930.)

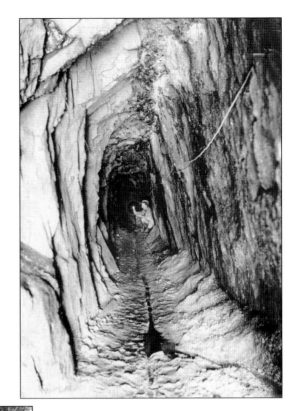

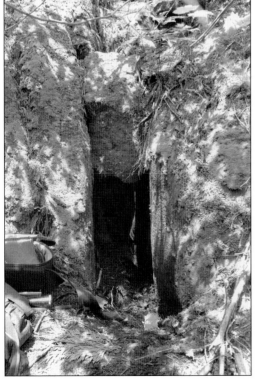

Intrepid explorers around Snoqualmie Pass still discover old mines, such as the one pictured here. Arthur Denny made the first mineral discovery in the area, using information he obtained from Native Americans. The Denny Iron Mines Company was formed in 1882. Though $7,000 was initially spent to develop the mines, the ore was found to be low grade and development ceased. (Courtesy Danny Miller.)

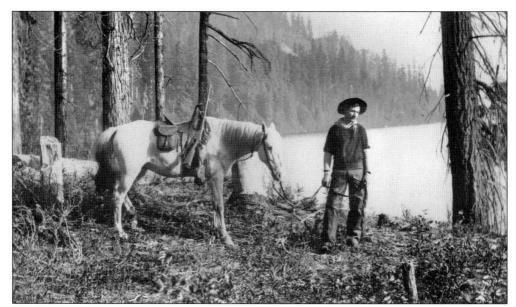

In 1901, Lawrence Lindsley, the grandson of David Denny, photographed himself with his saddle and packhorse, White Sam, at Lake Keechelus. Years later, Lindsley wrote, "We had just made a two and a half day trip from Licton Springs, Seattle [current Greenlake area]. Sam shows he is sure tired. The cabin is gone and lake has been raised so the ground is underwater. Across the lake the Snoqualmie Pass hiway [sic] has been blasted out and thousands of cars pass here every month. . . . This was the fastest trip we ever made as the usual run was about three days or so. We now make the same trip in auto in three or four hours. Some change." (Courtesy University of Washington Libraries, Special Collections, UW26830.)

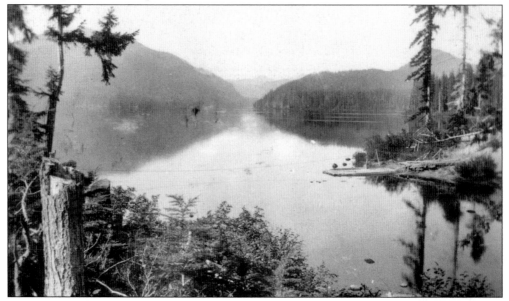

Lake Keechelus was still a natural lake when this photograph was taken in October 1896. Beginning in 1912, a ferry company offered passage so that motorists could avoid the unreliable wagon trail. Ferry service ceased soon after a road was completed around the lake in 1915. (Courtesy University of Washington Libraries, Special Collections, WAT103.)

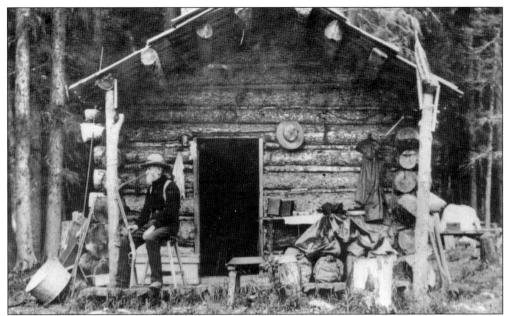

David Denny, a founding father of Seattle, kept a log cabin near his family's mining claims at Lake Keechelus. Adept at languages, David learned to communicate with the Native Americans, who referred to him as "Old Denny." In 1899, he went to work for the Highway Department and, from June through September, lived at the cabin, supervising the improvement of 27 miles of the old wagon road through Snoqualmie Pass. (Courtesy MOHAI, Sunset Highway Series-9441)

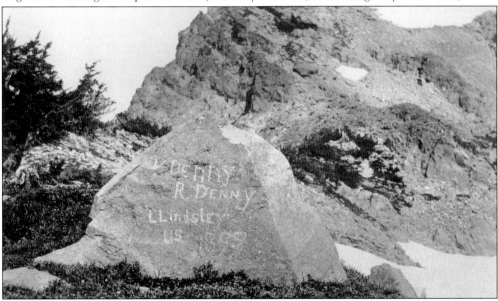

The Denny family engraved a six-foot boulder during the summer of 1899, while David Denny was supervising the improvement of the old Snoqualmie Pass road. The boulder is northwest of Four Brothers Peak, on the ridge above Gold Creek in Kittitas County. Although worn from many years of exposure on the ridge, the engraving is still visible, just as it is in this 1913 photograph: "V Denny, R Denny, L Lindsley, US 1899." (Courtesy University of Washington Libraries, Special Collections, UW26832.)

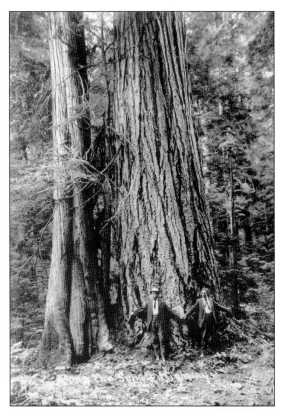

Two men measure the circumference of a large cedar tree near the Snoqualmie River. The forests west of Snoqualmie Pass initially contained a wealth of old growth cedars, many much larger than this one. The forests near Camp Mason and North Bend were heavily logged in the late 19th and early 20th centuries. (Courtesy Ellensburg Public Library.)

Before the development of a major highway, when people began flocking to Snoqualmie Pass in search of recreation, native flora existed relatively undisturbed. This trillium plant, photographed by Lawrence Lindsley above Source Lake on the Snow Lake Trail in the early 1900s, shows a prolific 22 blossoms. Conservationist groups, including the Mountaineers, later helped to educate the public about the need for protecting native wildflowers and plants in the Cascades. (Courtesy University of Washington Libraries, Special Collections, UW26929.)

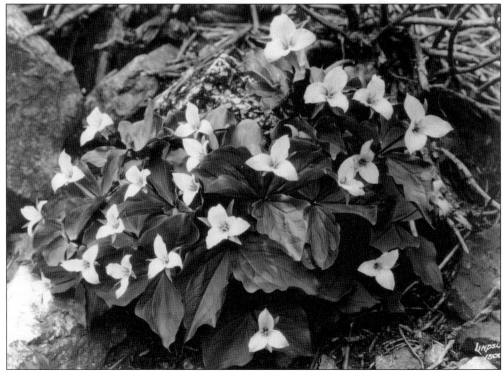

The first wagon road over Snoqualmie Pass was completed in 1868. The need for a route was realized as early as 1855, but surveying was not arranged until 10 years later. Shown here is a section of the old wagon road on the west side of the Pass, near Denny Creek. In the late 1960s, the Conservation Activity Camp Program of the Chief Seattle Council of Boy Scouts provided many hours of labor to restore a section of the historic road. (Courtesy Washington State Archives.)

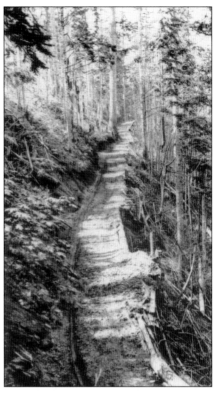

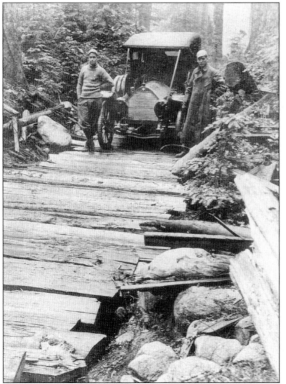

Split cedar planks called puncheons form a bridge across a boggy section of road west of the summit. The Alaska-Yukon Exposition of 1909, held in Seattle, created incentive for a better road connecting eastern and western Washington. Officials of the exposition promoted an auto race from New York to Seattle via Snoqualmie Pass, and some improvements resulted due to the publicity. However, the Highway Department did not begin making in-depth plans to improve and relocate sections of the route until 1926. (Courtesy Washington State Archives.)

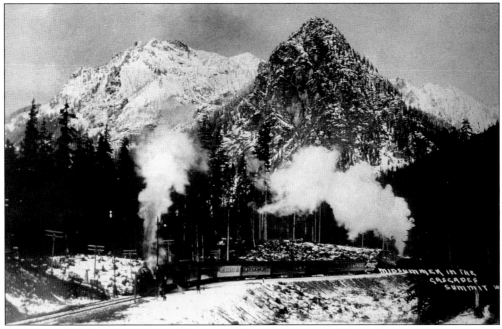

In this *c.* 1910 photograph, the old Sunset Highway runs parallel to the railroad tracks near Laconia Station, presided over by Mount Snoqualmie and Guye Peak, the dark, rocky peak on the right. Laconia was located below the slope that later became Municipal Hill, a ski area run by the Seattle Parks Department, the same area now known as Summit West. (Courtesy Arthur P. Carkeek family.)

In March 1909, the Chicago, Milwaukee, and St. Paul Railroad's main line was completed at Snoqualmie Pass, joining the Northern Pacific and Great Northern routes through Laconia. Shown here is a railroad trestle near Laconia Station at the summit. (Courtesy Ellensburg Public Library.)

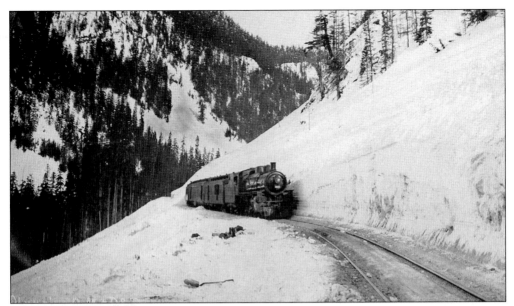

The *Olympian* rounds the track in the area later known as Airplane Curve, beneath Denny Mountain. The Chicago, Milwaukee, and Puget Sound Railway, part of the Chicago, Milwaukee, and St. Paul Railway, operated two daily passenger trains that crossed Snoqualmie Pass beginning in 1911: the *Olympian* and the *Columbian*. The *Olympian* had a faster schedule and was more luxurious. It later continued to serve the Chicago–Tacoma run and was finally re-equipped as a *Hiawatha* fleet streamliner. (Courtesy Arthur P. Carkeek family.)

The railroad tracks near Laconia Station have been cleared after a fresh snowfall around 1911. (Courtesy Arthur P. Carkeek family.)

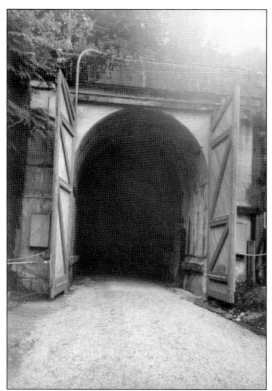

After the Milwaukee Railway was bankrupted, the tunnel extending from Rockdale to Hyak was sealed. Several decades later, the tracks were removed, and the tunnel was reopened during the summer of 1994 as part of the Iron Horse State Park trail system. The 2.3-mile-long tunnel has no lights; therefore, hikers, cyclists, and horse riders are required to bring along flashlights for visibility and safe passage. (Courtesy the authors.)

Construction of Snoqualmie Tunnel No. 50 progressed rapidly in 1913, supervised by H. C. Henry, the Chicago, Milwaukee, and St. Paul Railway contractor. Drilling in both the east and west ends simultaneously created a competition between the workers to see who could drill the farthest in one day. Completed in 1914, the tunnel runs from Rockdale to Hyak under the slopes of Summit Central, previously called Ski Acres. (Courtesy University of Washington Libraries, Special Collections, UW7574.)

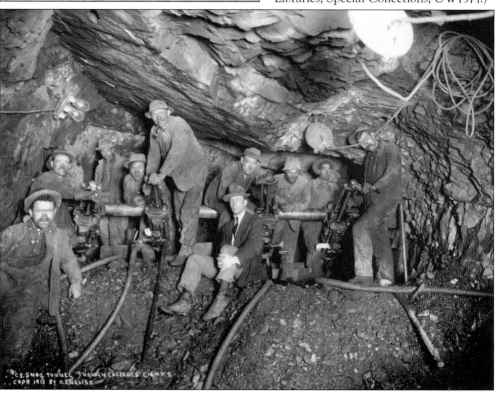

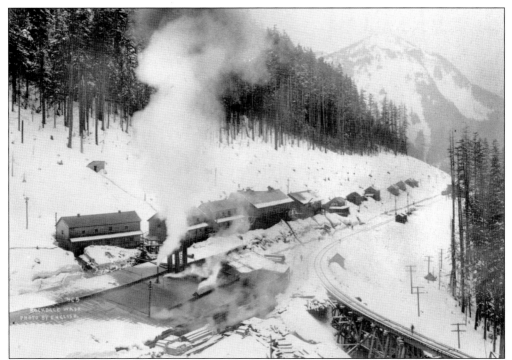

Rockdale, photographed about 1920, was situated near the west portal of the Milwaukee Railway tunnel through Snoqualmie Summit. When the railroad stopped running, Rockdale became deserted and was later dismantled. The first Mountaineers lodge at Snoqualmie Pass was built at Lodge Lake above Rockdale. (Courtesy University of Washington Libraries, Special Collections, UW10528.)

In 1915, Laconia was bypassed after the opening of the Snoqualmie Tunnel. Hyak Station, at the entrance to the east portal, became the main stop at Snoqualmie Pass. A small community sprang up in Hyak to serve railway employees, including a schoolhouse and post office. (Courtesy Jack Leeper.)

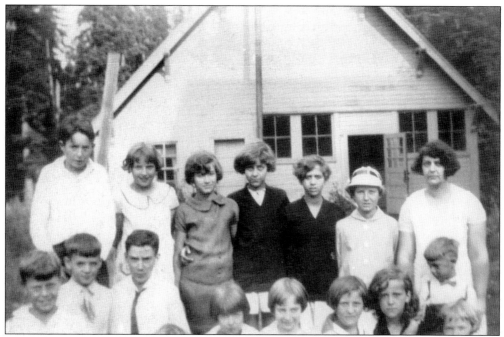

The Hyak School was started in the 1920s to provide local education to the children of Chicago, Milwaukee, and St. Paul Railway employees. Alexander Hamilton "Ham" Howard was a student at the school for two winters, from 1928 to 1929. His mother, Pearl Howard, served as the teacher. (Courtesy Ellensburg Public Library.)

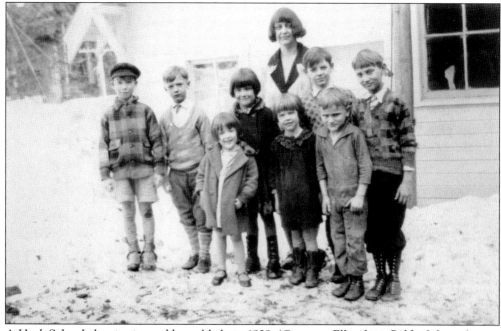

A Hyak School class is pictured here, likely in 1929. (Courtesy Ellensburg Public Library.)

The Sunset Highway between Denny Creek and Snoqualmie Summit involved many hairpin turns and could be treacherous even under the best of conditions. (Courtesy Washington State Archives.)

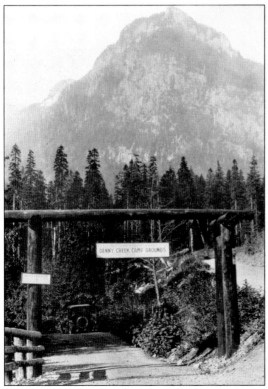

As automobile travel became more common, campgrounds began appearing along the Sunset Highway from Seattle to eastern Washington. Denny Creek Campground, still a popular destination with campers, is situated in deep forest just west of Snoqualmie Summit. (Courtesy University of Washington Libraries, Special Collections, WAS0236.)

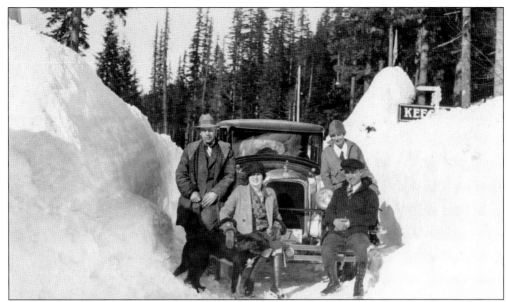

On February 13, 1927, members of a *Seattle Post-Intelligencer* motoring party stop near the Keechelus Inn, about six miles east of Snoqualmie Pass Summit. During the 1920s, permits were required to cross Snoqualmie Pass. The number of travelers was telephoned across the mountains, and search parties were sent out whenever someone failed to arrive. Travelers without permits were fined a hefty $250. (Courtesy Washington State Archives.)

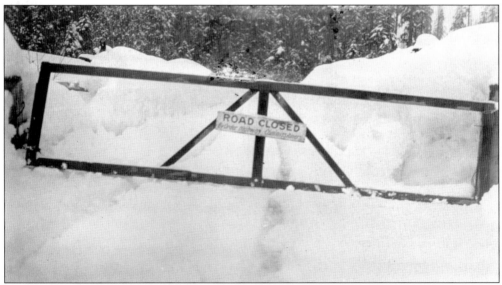

A barricade at Denny Creek prevents motorists from proceeding. Prior to 1931, the Highway Department did not have the ability to keep the road to Snoqualmie Summit open year-round. People who chose to ski from Denny Creek up to the summit were in for a several-hour trip, and skins were required over the wooden skis to allow for walking and climbing. At the summit, the skins were removed, and the hardy skiers would manage one glorious run in untracked snow, returning to their cars utterly spent. (Courtesy Washington State Archives.)

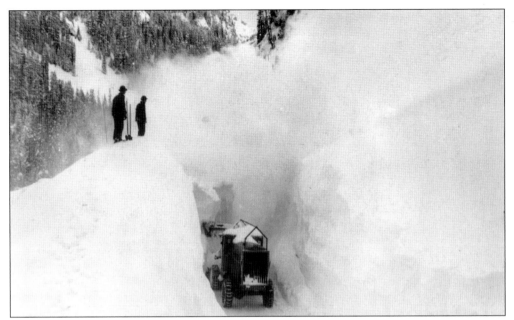

In 1931, the Washington State Highway Department began keeping the road through Snoqualmie Pass open all winter. Plowing snow to the uphill shoulder of the road proved insufficient to keep up with the annual Cascades snowfall of about 45 feet, with flakes sometimes falling at the rate of one foot per hour. In this 1936 photograph, a road crew uses a new snow blower to throw snow downhill and out of the way. (Courtesy MOHAI, PI-25280.)

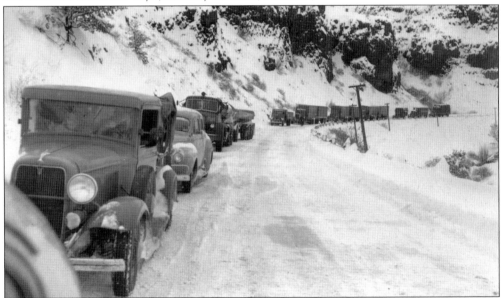

By the time these vehicles were stopped along the last incline to the summit in 1946, the road to Snoqualmie Pass had undergone many name changes. In 1905, the wagon route over the Pass was designated State Road No. 7; in 1913, the state numbering system was discontinued and the route was renamed the Sunset Highway; in 1923, the old gravel Sunset Highway was renumbered State Road No. 2; and in 1926, it became part of U.S. Highway No. 10, which evolved into a paved, four-lane highway following the current route of Interstate 90. (Courtesy MOHAI, PI-25290.)

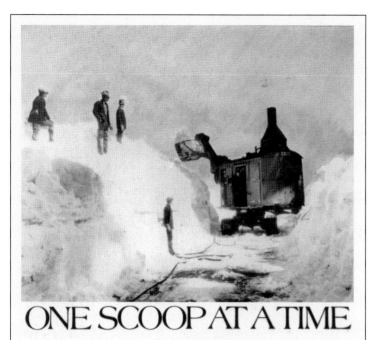

ONE SCOOP AT A TIME

The Washington State Highway Department created the following four posters from photographs of the early 1900s. "One Scoop at a Time" shows an early wood-burning, steam-operated snow shovel at work in 1921. (Courtesy Washington State Archives.)

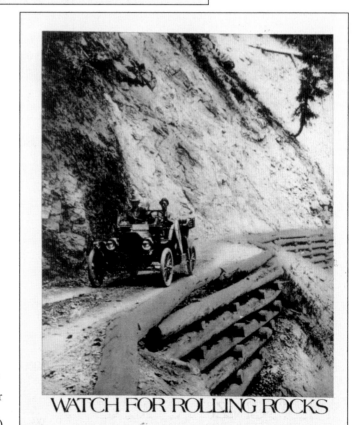

WATCH FOR ROLLING ROCKS

In the poster "Watch for Rolling Rocks," a car winds cautiously along a section of the old Sunset Highway near Lake Keechelus. (Courtesy Washington State Archives.)

With the primitive snow removal techniques of the early 20th century, heavy snowfall often resulted in greatly reduced road width, as shown in "A Tight Squeeze." (Courtesy Washington State Archives.)

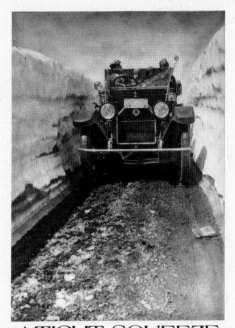

A TIGHT SQUEEZE

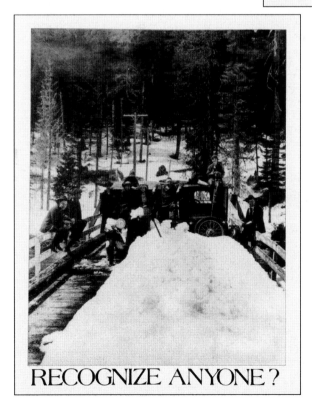

RECOGNIZE ANYONE ?

Motorists are unable to cross the Denny Creek Bridge on the Sunset Highway in the poster captioned "Recognize Anyone?" (Courtesy Washington State Archives.)

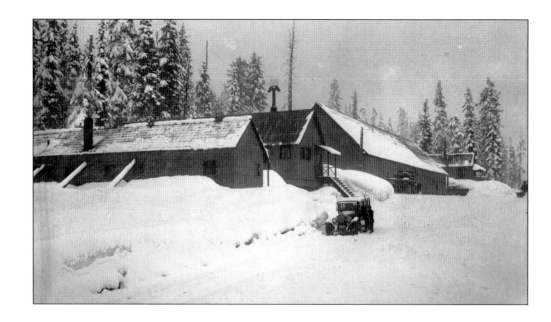

The Washington State Highway Department's maintenance camp was an important part of early snow removal operations at the Pass. The early camp was established in 1930. The bunkhouse above was a long, narrow room at 12 by 72 feet—basically six normal-sized bunkhouses (12 by 12 feet) placed end to end, with the inside walls knocked down. A huge coal-burning potbelly stove near the center of the room provided the only heat. There were no provisions for showers in the old facility, only one faucet with cold water. Also at the camp were a cookhouse, storage shed, and foreman's cottage (below). (Courtesy Washington State Archives.)

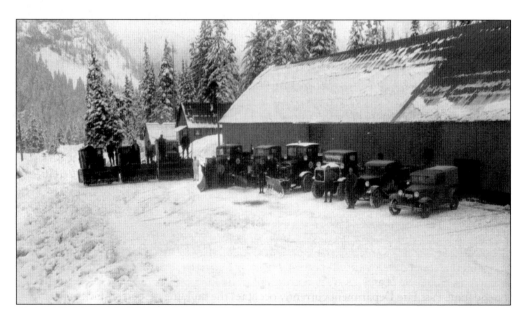

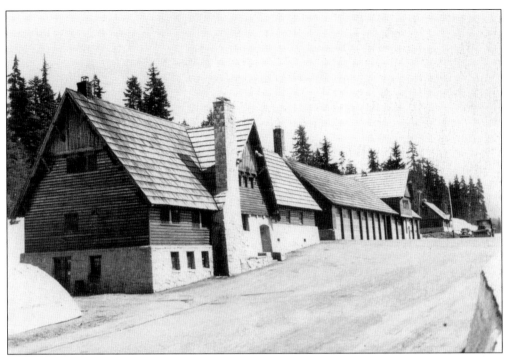

After the first maintenance camp dormitory burned down, two buildings were erected on site. The new dormitory contained enough sleeping space for 24 men, plus a dining room, lounge, and kitchen with a large walk-in freezer and ample storerooms. In 1949, the Highway Department had a crew of 30 men and equipment that included five rotary plows, eight push plows, three graders, and two bulldozers. (Courtesy Webb Moffett family.)

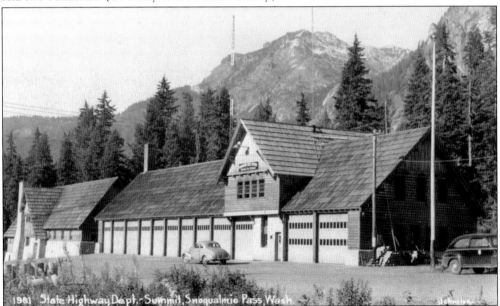

The building immediately next to the 1949 Highway Department dormitory at Snoqualmie Pass housed the State Patrol and also provided garages and offices for the Highway Department. The Snoqualmie Pass Fire Department currently occupies the building. (Courtesy Jack Leeper.)

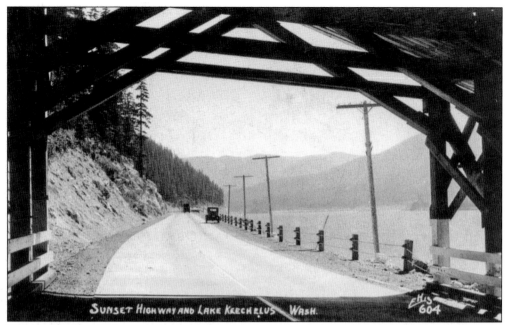

The initial snow shed near Lake Keechelus was constructed of wood. It was rebuilt in 1950, along with a new snow shed west of the summit along Airplane Curve. (Courtesy Jack Leeper.)

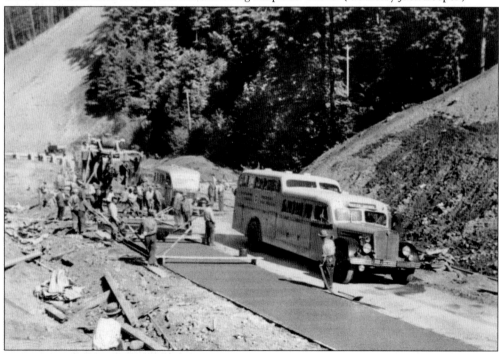

On September 18, 1937, road construction progressed on the last portion of the Sunset Highway, west of Snoqualmie Summit. Highway construction brought needed work to many people during the Depression years. Asahel Curtis snapped this photograph just as a unique-looking bus with a raised observation platform passed the work crew. (Courtesy University of Washington Libraries, Special Collections, A. Curtis 63078.)

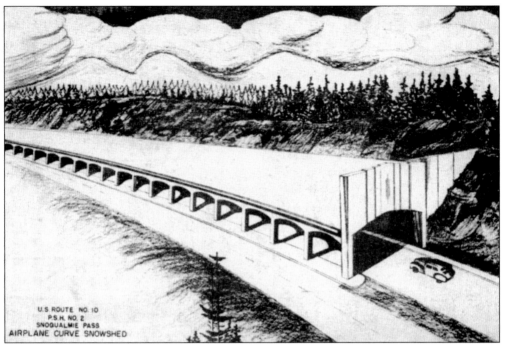

U.S. ROUTE NO. 10
P.S.H. NO. 2
SNOQUALMIE PASS
AIRPLANE CURVE SNOWSHED

This illustration of the proposed snow shed at Airplane Curve was on the front of an information card given to motorists who were temporarily stopped by construction along Highway 10 in 1950. The plan called for four lanes of pavement with a shed covering the inner two lanes. (Courtesy Jack Leeper.)

"WHY YOU WERE STOPPED"

The Department of Highways is trying to rush the completion of the snowsheds before next winter. The total snowfall on Snoqualmie Pass ranged from 333 inches in 1946-47 to 631 inches in 1948-49. The maximum depth at one time reached a high of 280 inches.

At Airplane Curve on the west side of the summit, massive snow slides occurred which covered the roadway from 6 feet to 20 feet in depth and for a distance of 1500 feet. Last winter the highway was closed for a total of 145 hours on account of slides.

C. V. Wilder Co. and Gaasland Co., Inc., of Bellingham, Wash., was awarded the contract for the construction of snowsheds at Airplane Curve and Lake Keechelus on February 28, 1950.

Contract Data

Airplane Curve Snowshed	Lake Keechelus Snowshed
Length - 1300'	Length - 500'
Vertical Clearance - 15'	Vertical Clearance - 15'
Pavement Width - 24'	Pavement Width - 24'

Cost - $1,120,000.00. Date for completion: November 1, 1950.
Your cooperation will be appreciated.

W. A. BUGGE
Director of Highways

The back of the information card "Why You Were Stopped" contained details about the Airplane Curve and Lake Keechelus snow sheds in progress. The Airplane Curve snow shed was immediately west of the summit, while the one at Lake Keechelus was situated several miles to the east. (Courtesy Jack Leeper.)

29

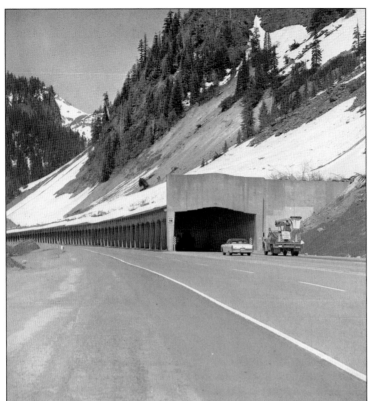

Snoqualmie ski area owner Webb Moffett was instrumental in obtaining the 5,000 necessary signatures to petition for the building of a snow shed on Airplane Curve, the site of repeated avalanches. The newly completed snow shed is seen here in the 1950s. (Courtesy Washington State Archives.)

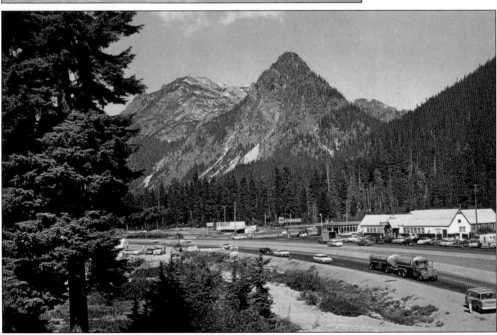

This 1960s postcard shows a stretch of U.S. Highway No. 10 through the summit. In the background are the most-recognized landmarks of Snoqualmie Pass: Mount Snoqualmie and Guye Peak. Along the right side of the highway are the old Summit Inn and Standard gas station.

Two

SEATTLE'S PLAYGROUND

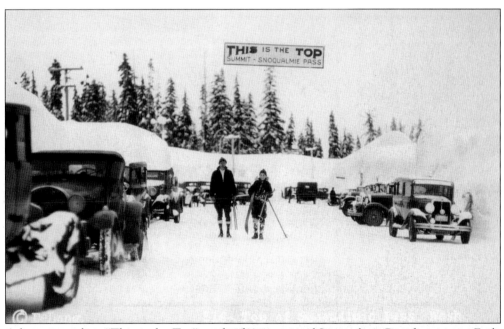

A banner reading "This is the Top" marks the summit of Snoqualmie Pass for visitors. Early skiing was a primitive sport involving a lot of hiking and/or telemarking. The owners of these cars lining the summit highway have most likely come to watch ski races or jump competitions. (Courtesy Jack Leeper.)

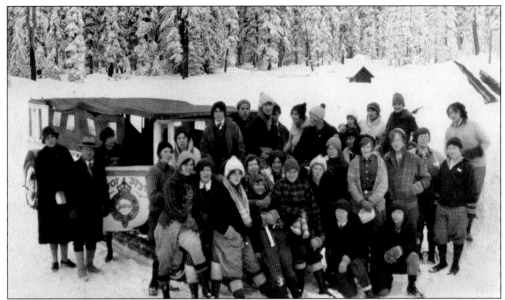

Harry B. Cunningham, a youth counselor in the Seattle school system, was responsible for the first ski bus to Snoqualmie Summit. Cunningham led groups of high school students on snowshoe outings to the Cascade foothills, as shown in this 1929 photograph. The destination was usually either Rockdale or Hyak, at either end of the Snoqualmie Tunnel. When Cunningham discovered that each snowshoe expedition contained a higher percentage of skiers, he began taking his students on ski trips. (Courtesy Webb Moffett family.)

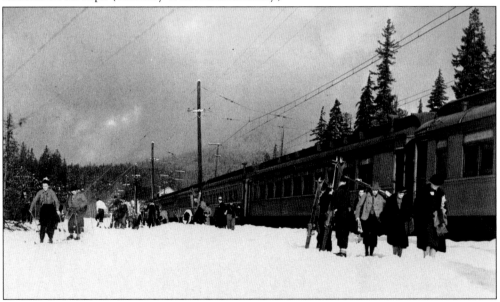

People leave a ski train at the Snoqualmie Ski Bowl in 1939. The Chicago, Milwaukee, and St. Paul Railroad operated ski trains to Snoqualmie Pass from 1937 to 1949. The railroad halted service for skiers after the lodge burned down in 1949, claiming the excursions were too expensive. The ski train ran winter weekends from Tacoma and Seattle, loading skiers at 8:30 a.m. and arriving at the Pass by 10:30. The train had a baggage car with a food bar and a jukebox and could be chartered for night parties. (Courtesy MOHAI, Seattle PI-26879.)

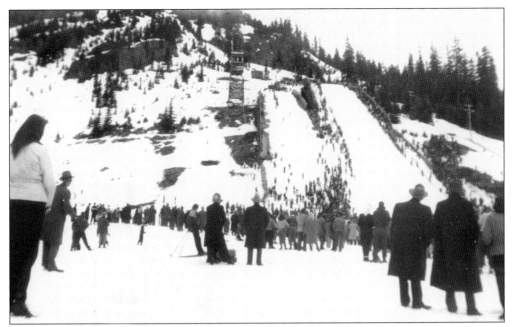

In 1947, when Olympic trials were held at the Milwaukee Ski Bowl, it had the largest ski jump in North America. (Courtesy Joy Lucas.)

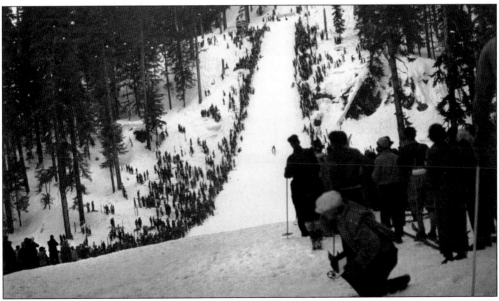

Prior to 1937, skiing in the Northwest was primarily a spectator sport. Hundreds of people hiked up the slope at Snoqualmie Summit on weekends to watch daredevil skiers, mostly Scandinavian immigrants, race at high speeds or fly over 250-foot jumps. (Courtesy Washington State Archives.)

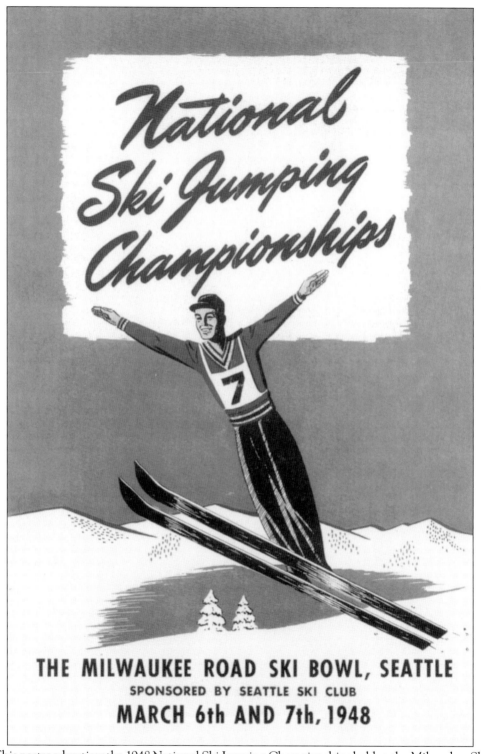

This poster advertises the 1948 National Ski Jumping Championships held at the Milwaukee Ski Bowl. (Courtesy Jack Leeper.)

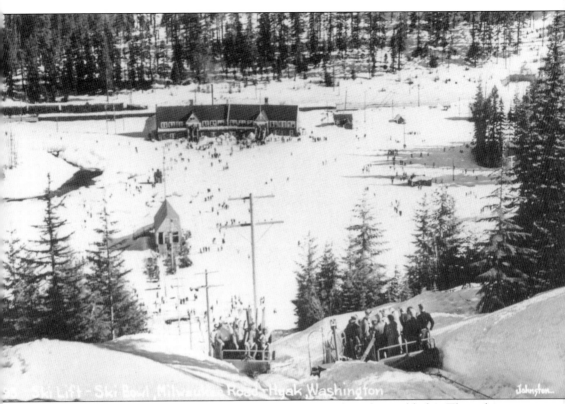

A skiboggan glides to the top of the slope above the Milwaukee Ski Bowl lodge. The only entry to the ski bowl was by train, and when the train arrived, mobs of skiers overran the rental shop on the lower floor of the lodge. All the skiers had to return the equipment at the same time, when the train arrived late in the afternoon to take everyone home. The routine rush was quite stressful for both skiers and rental shop staff. (Courtesy Jack Leeper.)

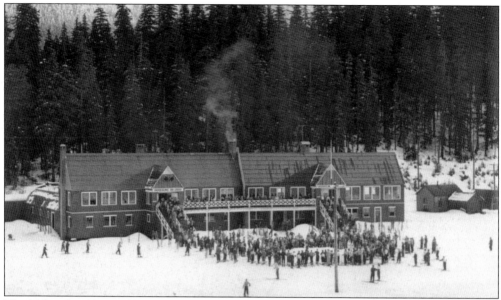

The Milwaukee Ski Bowl lodge was shaped like a large V, with windows all across the front. Music, continually blaring from speakers on the outside, could be heard all over the slopes. After the lodge burned down in 1949, the Seattle Times Ski School operated temporarily out of railroad cars. The next year, the railroad decided not to rebuild the lodge. The resort was closed and the ski school moved to Ski Acres. In 1959, the Hyak Ski Corporation purchased land just north of the ski bowl and redeveloped the area. (Courtesy Jack Leeper.)

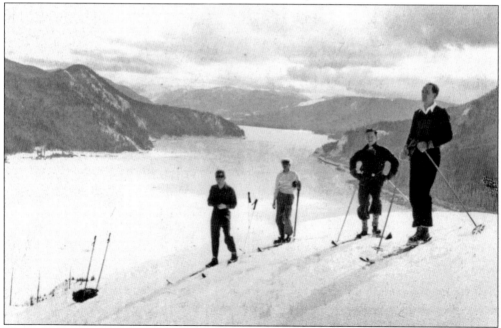

These skiers were photographed at a Snoqualmie Ski Bowl viewpoint around 1940. Lake Keechelus appears in the background, with Highway 10, the old Sunset Highway, along the east (left) shore and the Milwaukee Railway on the west (right) shore. (Courtesy University of Washington Libraries, Special Collections, UW26883.)

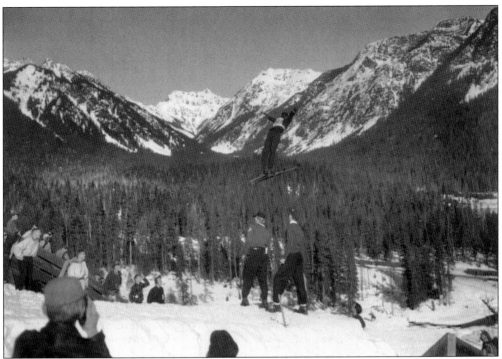

An athlete competes in the Olympic ski jump trials held at the Milwaukee Ski Bowl from March 22 to 23, 1947. (Courtesy MOHAI, Seattle PI-26891.)

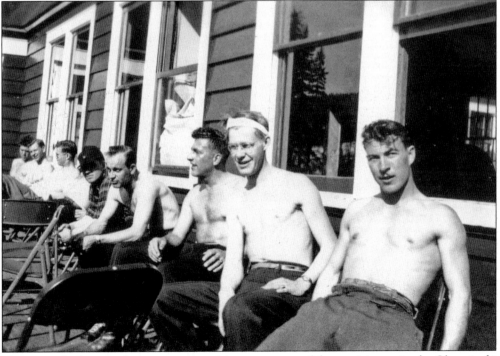

These men basking in the mountain sunshine were some of the participants in the Olympic ski jump trials at Snoqualmie Summit in March 1947. (Courtesy Joy Lucas.)

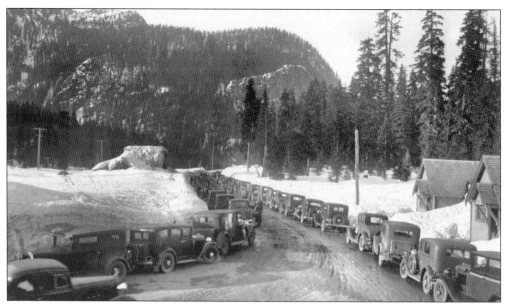

Ski competitions brought many visitors to the Pass, beginning around 1929. Early automobiles, looking like cookie-cutter images of each other, line the highway at the summit during a weekend event. (Courtesy Washington State Archives.)

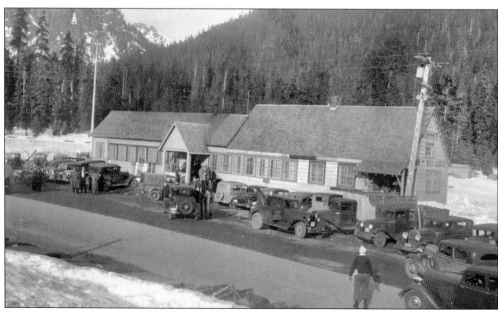

The old Summit Inn was located directly across from the ski area known as Municipal Hill, which later became the Snoqualmie Summit ski area. The inn provided the only lodging at the summit. (Courtesy Washington State Archives.)

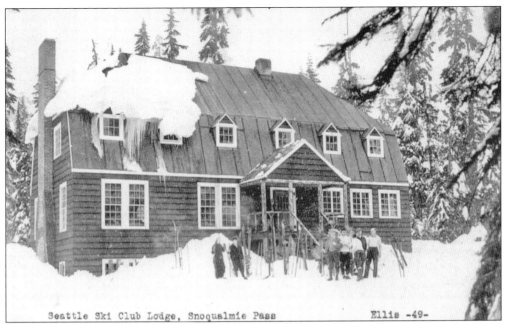

Seattle Ski Club Lodge, Snoqualmie Pass Ellis -49-

The Seattle Ski Club lodge was built at Snoqualmie Pass in the late 1920s. Most of the club's early members were Norwegian jumpers and cross-country skiers. The building had a kitchen, dining room, and large lobby on the first floor that was used for dances. Sleeping quarters were on the upper floor. Nearly every winter weekend, club members could be found on the Beaver Lake jumping hills. At night, they enjoyed singing and dancing to an accordion in the lodge. (Courtesy Jack Leeper.)

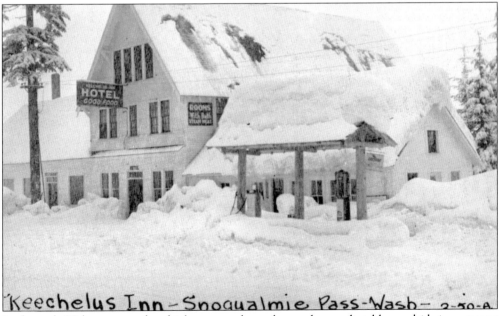

Keechelus Inn - Snoqualmie Pass - Wash - 2-50-A

In the early 20th century, when highway travel was slow and unpredictable, roadside inns sprang up every few miles. The Keechelus Inn was one of several stops east of Snoqualmie Pass. (Courtesy Jack Leeper.)

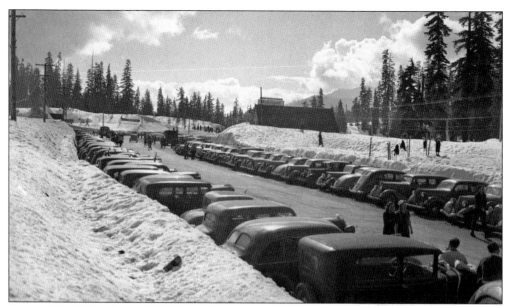

During World War II, gas rationing became a threat to the survival of local ski resorts. In order to continue enjoying the sport, skiers pooled rationing coupons and drove in groups to the Pass, which was closer to the Seattle metropolitan area than other ski resorts. By the start of the 1950s, Snoqualmie Pass was one of 22 better-known ski areas in Washington. The Washington State Advertising Commission attracted potential skiers with the slogan "Skiing's Great in Washington State." (Courtesy Washington State Archives.)

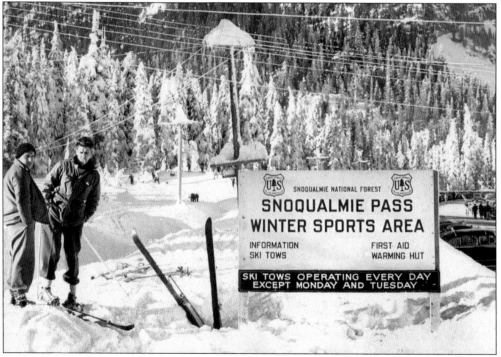

Soldiers take a break between ski runs at the summit in the 1940s. (Courtesy Webb Moffett family.)

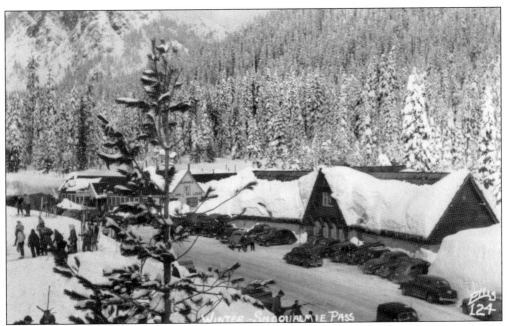

The Traveler's Rest at Snoqualmie Pass was built by the Highway Department as a rest stop for motorists. For many years, the building also housed a convenience store, Time Wise Grocery, which has since been replaced by a coffee shop. (Courtesy Jack Leeper.)

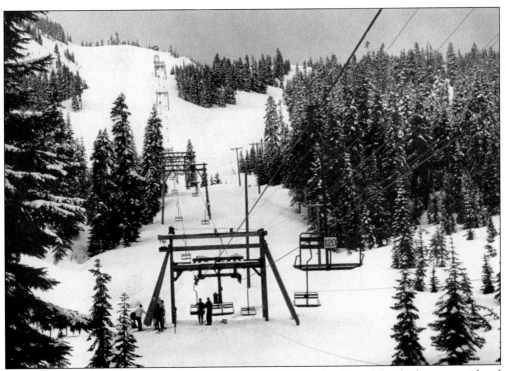

In 1952, Snoqualmie Summit replaced its original rope tow with a Poma lift, which was considered the Cadillac of surface transportation. (Courtesy Joy Lucas.)

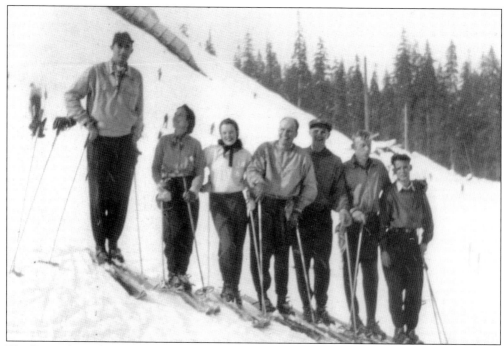

The Snoqualmie Ski Bowl's original ski instructors included, from left to right, Ralph Bromaghin, Clarice Syverson (auxiliary), Eileen Linnane Sarchett (auxiliary), Ken Syverson, Chuck Metzger, Al Lubberts, and Leo Spitzner. (Courtesy Joy Lucas.)

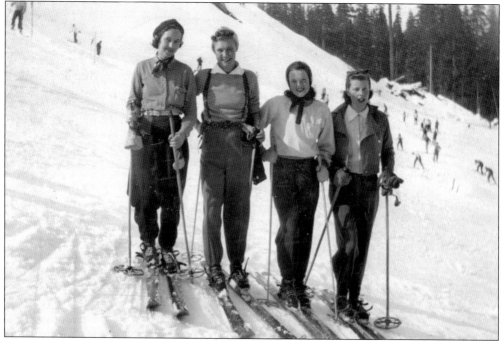

The auxiliary instructors at the Snoqualmie Ski Bowl were, from left to right, Clarice Syverson, Joy Lucas, Eileen Linnane Sarchett, and Lois Lent. All four women married ski instructors. (Courtesy Joy Lucas.)

Doris Harlacher, the first woman to be elected to the Professional Ski Instructors of America Board of Directors, checks the bindings of her class at Ski Acres in 1951. Even after improvements to the old wooden ski styles, women had trouble finding ones that fit properly. Jeannie Thoren of Sun Valley discovered that moving the bindings a half-inch forward of the normal mounting position more adequately balanced a woman's body mass and muscle structure. (Courtesy Joy Lucas.)

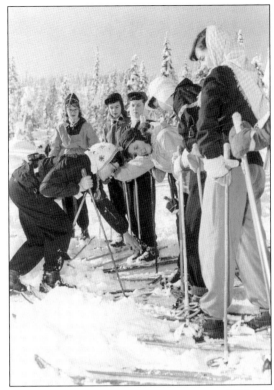

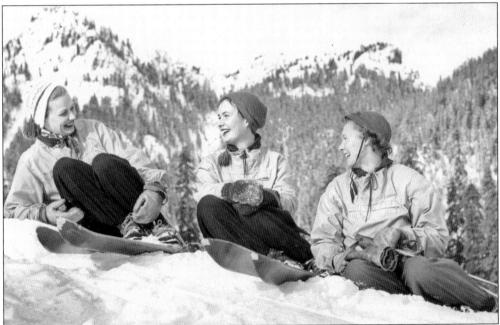

From left to right, Jackie Nelson, Eileen Barron, and Joy Lucas take a few moments to enjoy the sunshine and scenery on the slope at Snoqualmie Summit in 1954. The women and their husbands, all ski instructors with the Post-Intelligencer Ski School, formed three out of four ski teaching couples that devoted weekends to the sport they loved. (Courtesy Joy Lucas.)

Jim and Joy Lucas, pictured with their son David, met aboard the Snoqualmie ski train on January 23, 1938. It was Joy's first trip, and she quickly formed a bond with the young man across the aisle. The couple managed the Milwaukee Ski Bowl right after World War II and later instructed at Snoqualmie Pass. Jim and Joy Lucas helped organize the Pacific Northwest Ski Instructors Association (PNSIA) and were inducted into the Northwest Ski Hall of Fame—Joy in 1992 and Jim in 1994. In 1941, Joy became the first woman certified ski instructor in the country. Jim retired at age 75 as the oldest active ski examiner in the nation. (Courtesy Joy Lucas.)

Bill Durant, shown here with his future wife, Marie Jacobucci, was assistant director of the Post-Intelligencer Ski School and a teacher at the Snoqualmie Ski Bowl in the late 1930s. When he died at age 47, he was preparing for the opening of his Washington Athletic Club Ski School. The Big Bill chair lift at Snoqualmie Summit was named in his honor. (Courtesy Joy Lucas.)

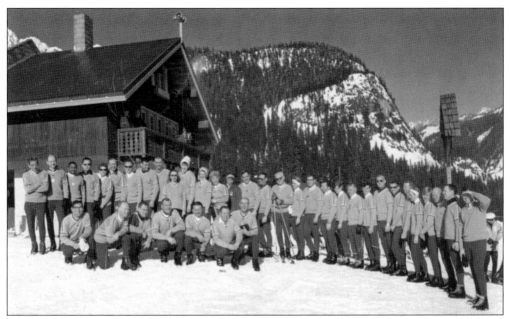

This group photograph of Greater Seattle Ski School instructors was taken around 1967. The ski school was the largest in the Pacific Northwest during the 1960s. When the school's new headquarters was built at Snoqualmie Summit, ski instructors doubled as painters, carpenters, roofers, and electricians, finishing their chalet just in time for the Christmas holiday rush. (Courtesy Webb Moffett family.)

Nobi Kano, a nisei who became a ski instructor for U.S. Army mountain troops in Colorado during World War II, formed Rokka Ski School. He was the first Japanese to be certified as a ski instructor in the Seattle area after the war. Rokka Ski School served as a club for people of Japanese ancestry and attracted interesting guests to Snoqualmie Summit, including the Japanese consul's wife. (Courtesy Webb Moffett family.)

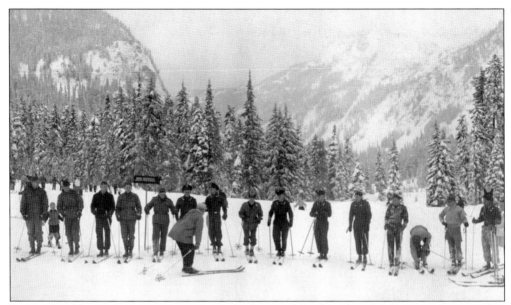

During World War II, Mount Rainier was the home of the famed 10th Mountain Division, but Snoqualmie Summit also taught many soldiers the basics of skiing. Soldiers in the division learned the military Arlberg technique used to train Austrian troops. In the 1980s, Webb Moffett granted free skiing to division veterans and invited them to hold their annual Ski-In at Snoqualmie Pass. The old Mountain Troopers returned year after year to make one more run down the slopes together and talk about old times. (Courtesy Webb Moffett family.)

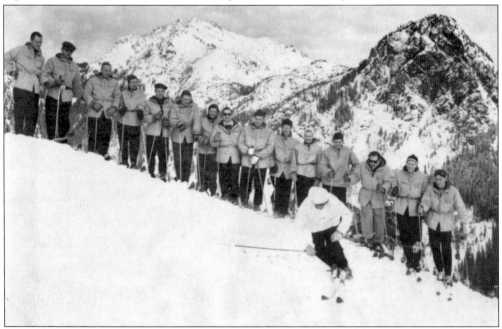

Sigi Engl, director of the Sun Valley Ski School, shows 1953 Seattle Post-Intelligencer Ski School instructors how to perform a Christiania turn. The instructors are wearing the Seattle Post-Intelligencer Ski School uniform, which included a gray-and-red White Stag quilted parka. (Courtesy Webb Moffett family.)

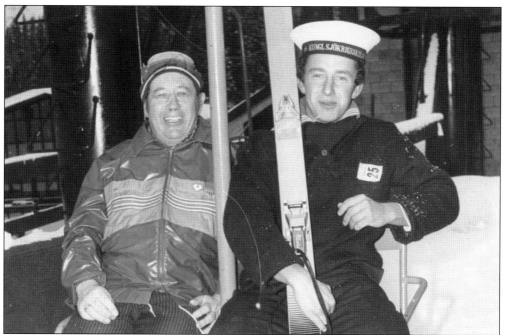

During the 1972–1973 season, Snoqualmie Summit hosted ski lessons and entertainment for the crew of the HMS *Alvsnabben*, Royal Swedish Navy, as part of the American at Home Program. The program was designed to introduce foreigners to the American way of life. Seattle mayor Wes Ulhman later sent a letter of thanks to Webb and Virginia Moffett on behalf of the Seattle Hospitality Committee. Praises for the program were also received through the Swedish consul. (Courtesy Webb Moffett family.)

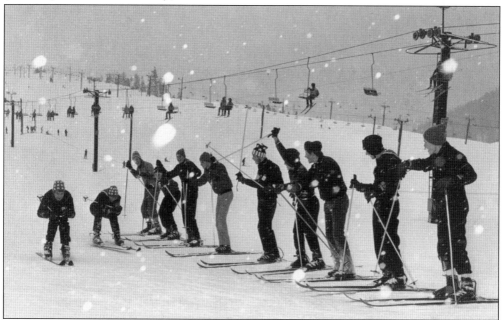

Crew members of the HMS *Alvsnabben* enjoy a rowdy competition on the slope at Snoqualmie Summit. (Courtesy Webb Moffett family.)

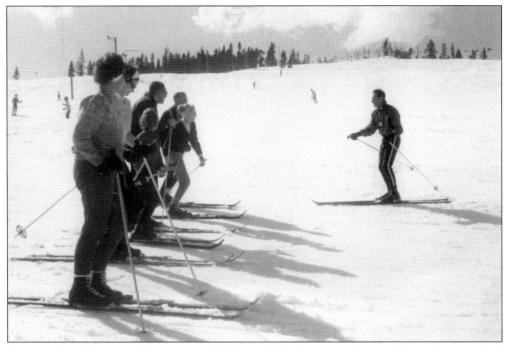

Competitive ski racer and instructor Adi Hienzsch leads a group lesson. Hienzsch supervised the resident ski school at the summit. The first instructor hired by Alpental Ski Resort, he also served as its ski school supervisor. (Courtesy Adi and Eva Hienzsch.)

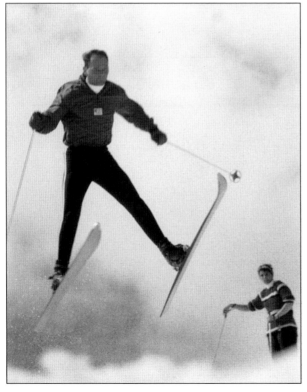

Adi Hienzsch performs an aerial stunt against a background of clouds. Hienzsch and his wife, Eva, immigrated to the United States from the Bavarian village of Garmisch, Germany, near the Austrian border. The couple lived in Alpental from 1980 to 1990 and managed the Alpenrose condominiums. (Courtesy Adi and Eva Hienzsch.)

Eva Hienzsch taught for the resident ski school at Snoqualmie Summit along with her husband, Adi. She served as the head cashier at Alpental for two years when it opened in 1967 and also worked at the gift shop. (Courtesy Adi and Eva Hienzsch.)

Snoqualmie Summit became a popular location for night skiing. An advertisement brochure entitled "The Skier's Good Book," illustrated by Bob Crane, promoted night skiing in this humorous manner: "Swing shift skiing means fun and runs from 2 'til 10:30 every day but Monday. You get more room to move, you get more skiing, and you get more boffs for your bread . . . dig?" Another ski resort advertisement professed that "Swingers Ski More for Less." (Courtesy Webb Moffett family.)

49

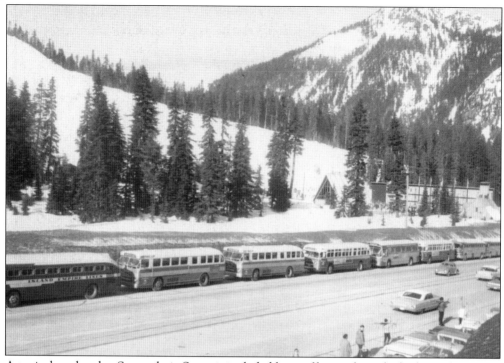

A typical weekend at Snoqualmie Summit included lines of buses along the highway. (Courtesy Adi and Eva Hienzsch.)

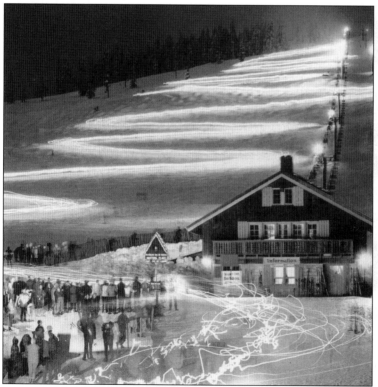

Few things are more enchanting than a winter torchlight parade, as demonstrated here through time-lapse photography at Snoqualmie Summit. Ski area employees, mostly instructors or ski patrol, gather at the top of the slope and slowly ski down in practiced formation with their torches, while maintaining a 10- to-15-foot distance from one another. The effect creates a festival for the eyes. (Courtesy Adi and Eva Hienzsch.)

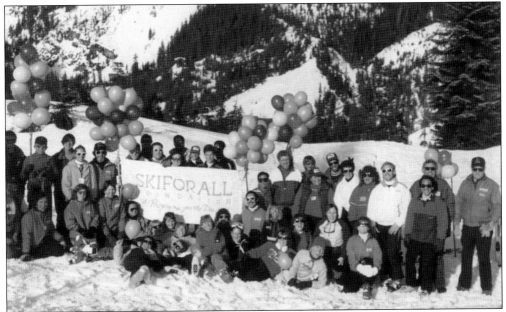

The SKIFORALL Foundation began as a nonprofit ski school for people with disabilities. Hugh and Dollie Armstrong, the parents of Olympic gold medallist Deb Armstrong, were instrumental in developing the program. Webb Moffett, the owner of the Snoqualmie ski area, served on the foundation's board of directors. This staff photograph was taken at Snoqualmie Summit in 1988. (Courtesy Outdoors for All Foundation.)

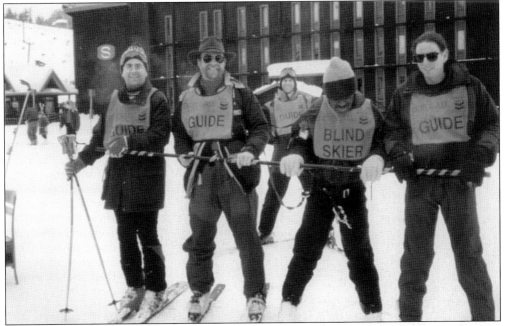

"You can do it" was the motto of the SKIFORALL Foundation. Now known as the Outdoors for All Foundation, the organization continues to honor its mission to improve the lives of children and adults with disabilities through year-round outdoor recreation. (Courtesy Outdoors for All Foundation.)

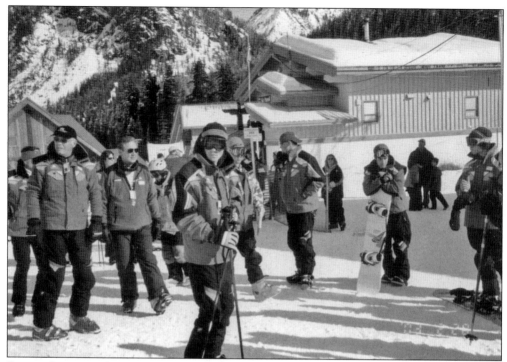

Summit Learning Center instructors Bob Baxter (far left) and Luke Gjurasic (second from left) await their class assignments on this day in the 1990s. (Courtesy Bob and Lois Baxter.)

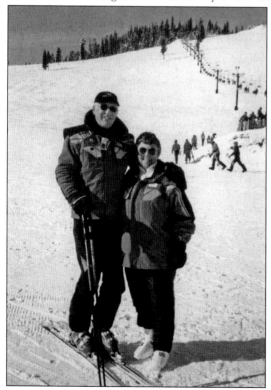

Bob and Lois Baxter, husband and wife, both taught for the Snoqualmie Ski School and won co-instructor of the year awards. (Courtesy Bob and Lois Baxter.)

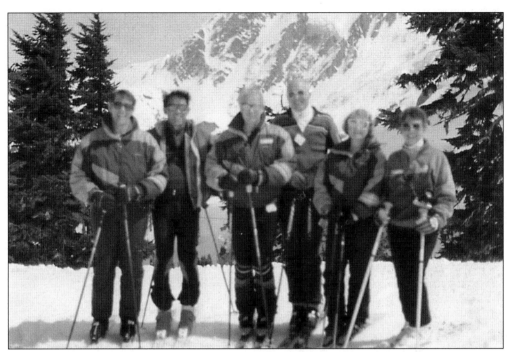

From left to right, Jim McCommon, Jim Yee, John Kinnick, Bob Baxter, Nancy Ferman, and Lois Baxter were instructors for Snoqualmie Ski School in the early 1990s. Their ski school uniform consisted of a royal-and-light-blue jacket with bright pink trim. (Courtesy the authors.)

Richard "Dick" Noble supervised the resident ski school at the summit and worked several seasons as a full-time pro-patroller. In this 1990s photograph, he wears the Snoqualmie Ski School jacket introduced after the uniform worn by the instructors in the above image. Dick and Carol Noble lived in one of the old Milwaukee Railway houses near the east portal of the Snoqualmie Tunnel at Hyak. (Courtesy Bob and Lois Baxter.)

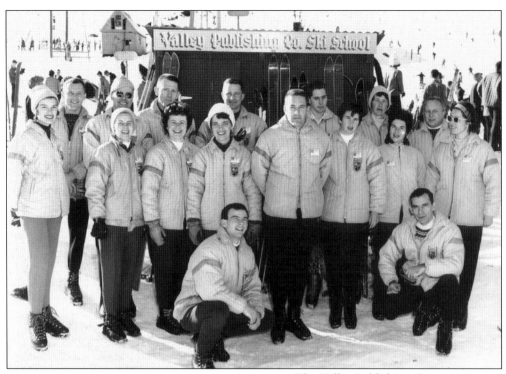

The Valley Publishing Company Ski School later became the John Mohan Ski School based at Ski Acres. The practice of using concession ski schools started shortly after Webb and Virginia Moffett founded the Snoqualmie ski area in the late 1930s. The *Seattle Times* and the *Seattle Post-Intelligencer* sponsored the first schools. (Courtesy John Mohan.)

Walt Hiltner (left) and John Mohan are freestyle examiners and co-authors of *Freestyle Skiing and Fundamentals*, first published in 1976. (Courtesy John Mohan.)

The 360 diamond ski run at Ski Acres, now Summit Central, is one of the steepest night runs in the country. (Courtesy John Mohan.)

John Mohan, the owner and operator of the main ski school at Ski Acres, invented the Racer Chaser, a harness system devised to control the speed of beginning skiers, especially children and the handicapped. Mohan was also the first to use numbered bibs to identify members of the same ski class. The bibs proved to be a useful method of keeping track of energetic youngsters. (Courtesy John Mohan.)

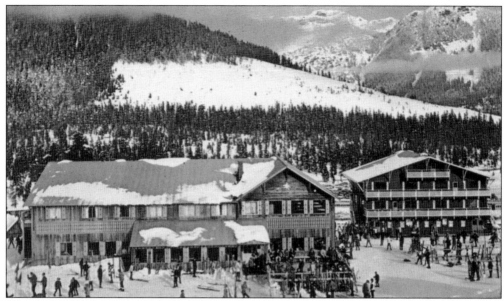

This postcard shows a view of the buildings at Ski Acres from the slope above and looking eastward. In 1946, a butcher named Reider Ray Tanner went looking for a family cabin with the help of a real estate agent. Instead of buying a cabin, Tanner was talked into purchasing half-ownership of railroad land just east of Snoqualmie Summit. The area was later developed into the resort called Ski Acres. (Courtesy Jack Leeper.)

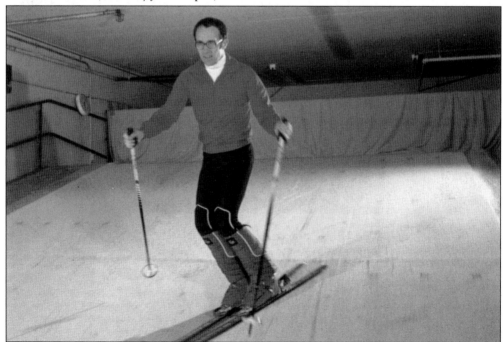

John Mohan demonstrates ski turns on an indoor practice ramp near Northgate Mall in Seattle. Indoor ramps, covered with carpet, make it possible for year-round ski and snowboard instruction. Ramps also provide a way for experts to engage in ski aerobics no matter what the weather. (Courtesy John Mohan.)

Alpental Ski School instructors gather for a photograph in the 1980s. (Courtesy Hugh and Dollie Armstrong.)

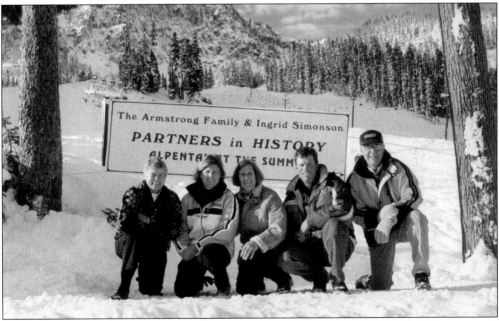

Ingrid Simonson (far left) owned and directed the Alpental Ski School until 1999. She is pictured with the Armstrong family during the dedication of the Armstrong Express chair lift in 1998. A former ski racer and coach of national rank, Simonson has resided at Snoqualmie Pass for most of her years since becoming Alpental Ski School owner/director. She is currently the president of the Pacific Northwest Ski Association and is still very active in race coaching and other events within the ski community. (Courtesy Hugh and Dollie Armstrong.)

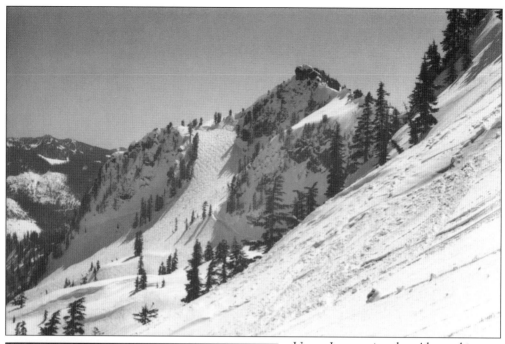

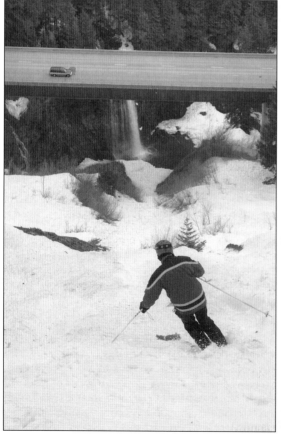

Upper International at Alpental is one of the most challenging inbound runs in the country. The only double-diamond run at Snoqualmie Pass, it has an average of over 42 degrees slope and moguls that build to the size of Volkswagen buses. The terrain of Upper International attracts filmmakers like Warren Miller, who has shot spectacular footage at Alpental for use in his popular ski movies. (Courtesy Danny Miller.)

Backcountry skiers have plenty of opportunity for thrills at Snoqualmie Pass. In this image, Danny Miller skis down the back of Denny Mountain with the Interstate 90 viaduct and Franklin Falls visible below. (Courtesy Danny Miller.)

Three

A MOUNTAINEER
AND HIS CABIN

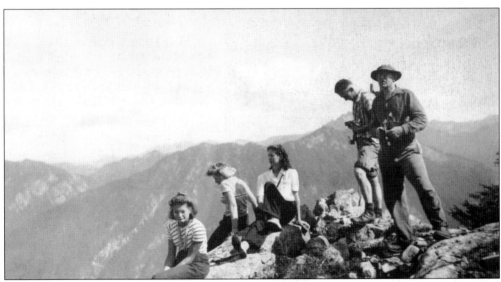

Arthur Penryn Carkeek, the nephew of early Seattle business magnate Morgan J. Carkeek and his wife, Emily, was an avid outdoorsman throughout his life. Carkeek kept a cabin at Snoqualmie Pass for many decades and enjoyed outdoor recreation nearly every weekend. He was one of the initial participants in the Seattle Mountaineers Club, which he joined formally at age 18. In this photograph, Art Carkeek (far right) takes in the view from atop Mount Snoqualmie with his fellow hikers. (Courtesy Arthur P. Carkeek family.)

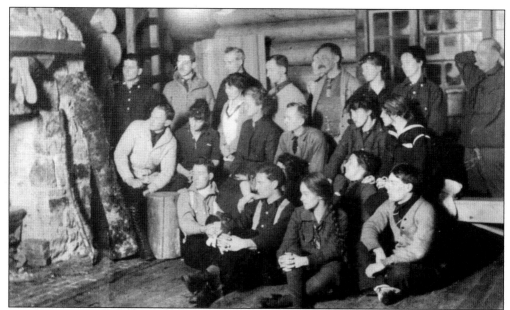

Mountaineers Club members pose beside the large stone fireplace inside the original Snoqualmie Lodge near Lodge Lake about 1918. Art Carkeek, wearing a light-colored sweater, is immediately next to the fireplace, and his wife, Carrie (Jenft), is seated beside him. The lodge was built in 1914 almost entirely of materials on the site. The first floor housed a 30-by-34-foot main room, a kitchen, and a women's dorm, while the men's dorm was in the attic above. (Courtesy Arthur P. Carkeek family.)

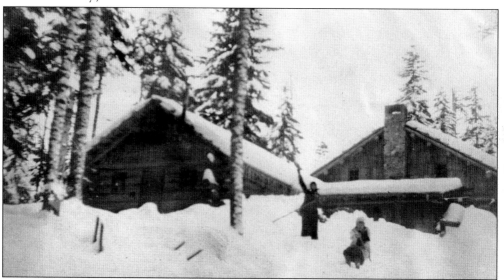

The only wintertime access to the Snoqualmie Lodge, pictured here about 1918, was by train to Rockdale Station, near the west portal of the Milwaukee Railway tunnel. After being dropped off alongside the tracks, passengers hiked up a steep slope. The lodge burned to the ground in 1944 when a spark made its way through the unlined chimney and set the shingled roof on fire. In 1948, another lodge was constructed adjacent to the Snoqualmie Summit ski area and was later placed on the Washington Register of Historic Places. The new lodge, also ill fated, was destroyed by fire in May 2006. (Courtesy Arthur P. Carkeek family.)

Carl Gould, a Mountaineers Club member, designed the Snoqualmie Lodge at Rockdale. At the time, Gould was one of a few Seattle-area architects with extensive training in the profession, having studied in Paris, interned in New York, and participated in several national design competitions. These design sketches were completed for the Mountaineers in January 1914. Shown are the front and rear elevations (above) and the front elevation and section sketches (below). (University of Washington Libraries, Special Collections, UW26884 and UW26885.)

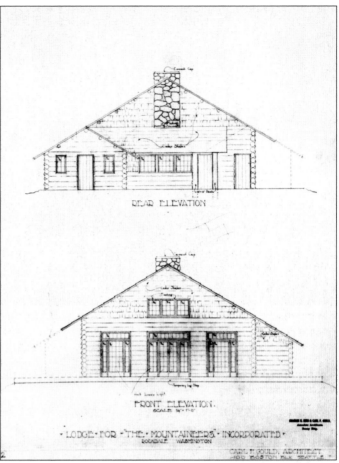

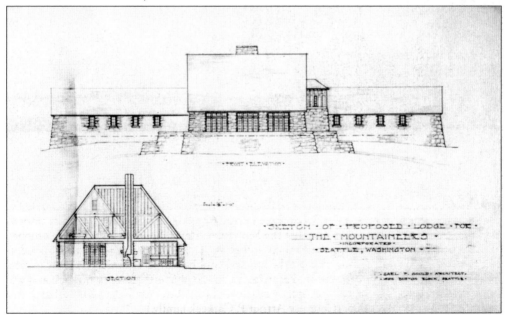

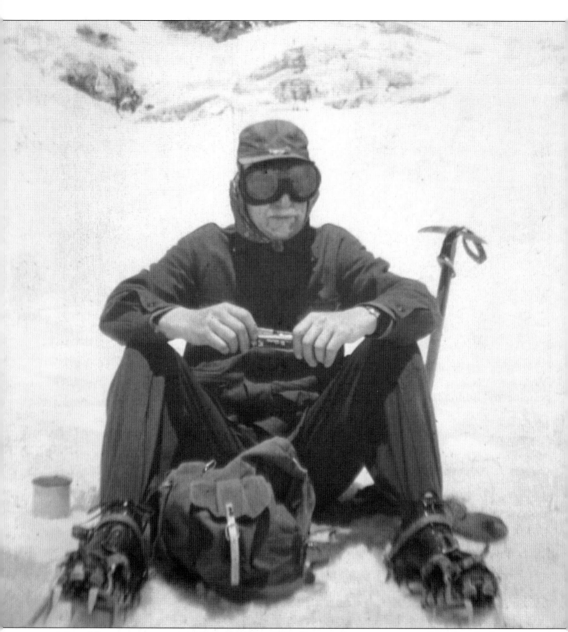

Many Mountaineers were profoundly affected by their outdoor experiences, like the climber pictured here. Art Carkeek, when interviewed for a 1979 article in the club's journal, the *Mountaineer*, indicated that his own long experience with the Mountaineers had been wonderful. Although club discipline was lacking on some of the early outings, he benefited greatly by learning how to take care of himself in the mountains. (Courtesy Arthur P. Carkeek family.)

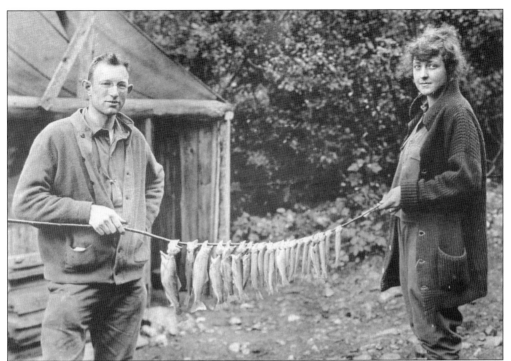

After Art and Carrie Carkeek married, they shared many outdoor activities together, including camping and fishing in the Cascade Mountains. (Courtesy Arthur P. Carkeek family.)

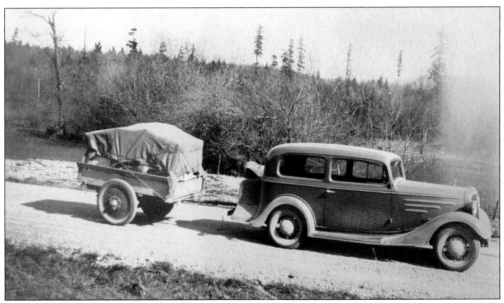

The Carkeeks' automobile is shown with a trailer fully packed for a camping expedition. (Courtesy Arthur P. Carkeek family.)

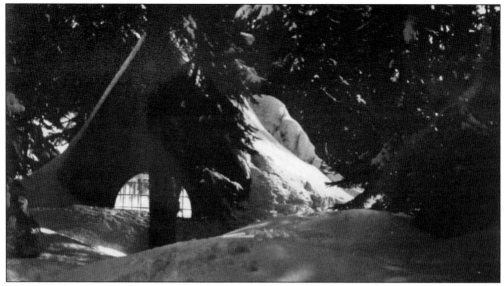

Art Carkeek's cabin at the Pass stands alongside the South Fork Snoqualmie River in what is now known as the Alpental Valley. Carkeek captured this night scene, showing the combination of moonlight on the cabin roof and interior lights casting a glow on pristine snow banks. (Courtesy Arthur P. Carkeek family.)

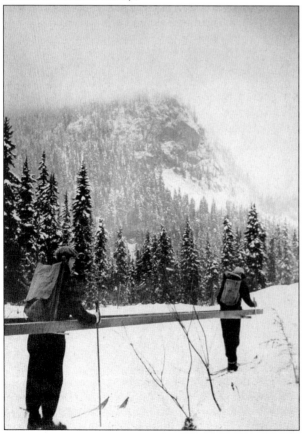

The Carkeek cabin at Snoqualmie Pass was constructed in the early 1940s. In winter, building materials had to be skied in from the highway, a mile away. (Courtesy Arthur P. Carkeek family.)

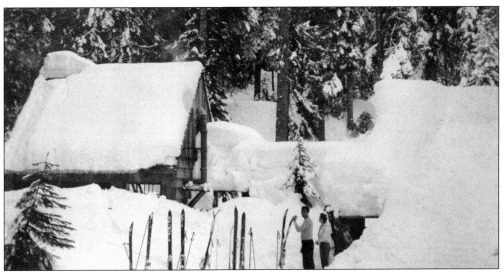

The area surrounding the Carkeek cabin was regularly decorated with skis and poles like ornaments in a Christmas holiday display. (Courtesy Arthur P. Carkeek family.)

During times of heavy snowfall, it was difficult to keep the entrances to isolated dwellings cleared. When the Carkeeks arrived at the Pass at week's end, they sometimes had to dig a cave to reach the door. (Courtesy Arthur P. Carkeek family.)

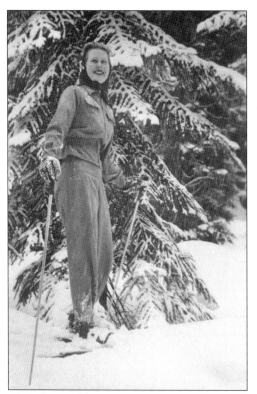

Many people enjoyed the hospitality of the Carkeek cabin, including this glamorous young skier. Today the Pass is only an hour's drive from metropolitan Seattle, but in the 1940s, it was a trip of several hours' duration. Snoqualmie Pass was an exciting destination that provided an escape from wartime concerns, as well as from parental supervision—an added attraction to young adults with visions of romantic adventures among the pines. (Courtesy Arthur P. Carkeek family.)

Before a road was cut into the South Fork Snoqualmie River Valley for Alpental developments in the 1960s, the only winter access was by skiing or snowshoeing. Visitors to the cabin parked their cars along the highway at the summit and often returned to find them buried in deep snow. (Courtesy Arthur P. Carkeek family.)

The Carkeek cabin consists of two buildings: a main cabin and a storage woodshed. Here Art and Carrie Carkeek retrieve their skis from the woodshed in the 1940s. (Courtesy Arthur P. Carkeek family.)

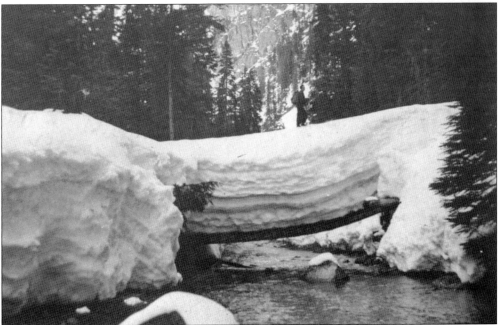

A winter hiker stands on a bridge upstream of the Carkeek cabin, entirely dwarfed by the thick snow load beneath. Not too long afterward, the bridge collapsed under the pressing weight. (Courtesy Arthur P. Carkeek family.)

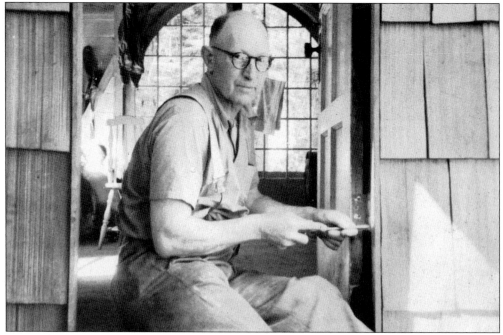

Art Carkeek repairs his door. True to the ways of a naturalist, he built the cabin using many salvaged materials, including the arched and paned windows, which were obtained from an old cathedral. (Courtesy Arthur P. Carkeek family.)

The cabin's interior contains a woodstove, a cook stove, several bunk-style beds, and a large table next to the window. Over the decades, the family kept ledger books to serve as a record of the comings and goings of visitors. In this photograph, Art and Carrie Carkeek's youngest son, Dick Carkeek, and his wife, Donna, gaze at the forest and river scene while enjoying a bite to eat at the family table. (Courtesy Arthur P. Carkeek family.)

Everyone in the family was encouraged to participate in outdoor activities, even the youngest. Nan and Bill Carkeek carry their firstborn son, Steven, along the path to the cabin in a bassinet. (Courtesy Arthur P. Carkeek family.)

Spectacular mountain scenery is enjoyed during a family hike to Melakwa Pass in 1944. (Courtesy Arthur P. Carkeek family.)

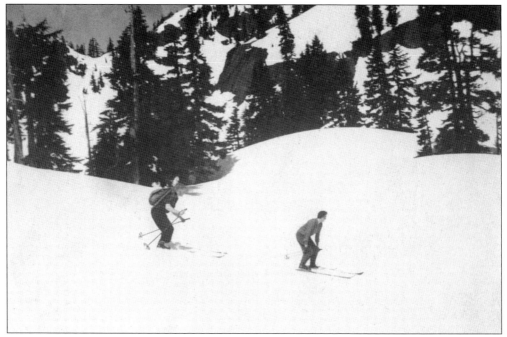

Ski equipment during the post–World War II years was cumbersome and heavy and often consisted of surplus army gear. Wooden skis were long and wide, and proper waxing was critical. For uphill climbs, skins made from canvas were placed over the skis to allow enough grip to prevent sliding backwards. (Courtesy Arthur P. Carkeek family.)

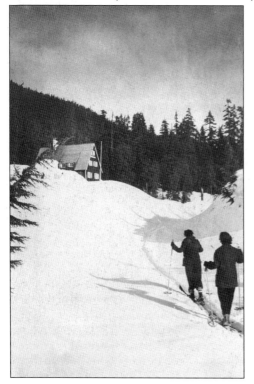

Two women ski along what would later become Alpental Road. By 1935, square-toed ski boots with rugged soles and grooved heels were available. They came in a variety of widths, so that women no longer had to settle for ill-fitting men's sizes. (Courtesy Arthur P. Carkeek family.)

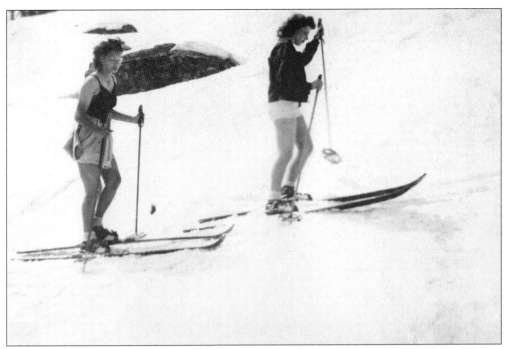

Spring skiing has always been a particular joy for many people, including these women, who are unencumbered by heavy winter clothing on a cross-country outing to Franklin Falls in the 1940s. (Courtesy Arthur P. Carkeek family.)

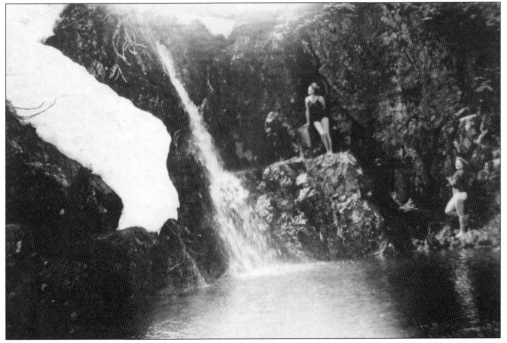

Swim-suited spring skiers contemplate an icy dip at Franklin Falls. The setting could be mistaken for a tropical pool, if not for the telltale embankment covered in snow. (Courtesy Arthur P. Carkeek family.)

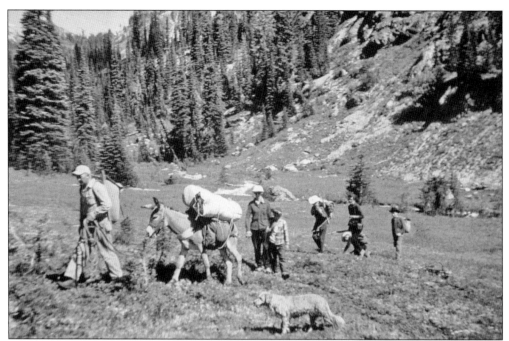

Bill Carkeek (far left) leads hikers, the family dog, and Art Carkeek's pack burro Jenny through an alpine meadow near Deep Lake. The burro made it possible for the Carkeeks to go on longer backpacking trips in the Cascade Mountains. (Courtesy Arthur P. Carkeek family.)

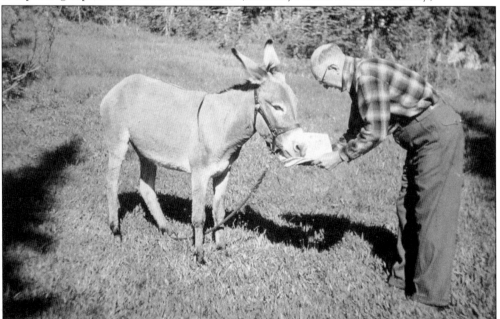

Art Carkeek offers Jenny a snack from a folded newspaper. Children were often put on the burro's back to ride while the adults hiked. Jenny, though a faithful helper, could be self-serving whenever she encountered thistles along a path. When the burro detoured through underbrush to get at the prickly treats, heedless of any exposed arms or legs dangling at her sides, there were some very unhappy youngsters. (Courtesy Arthur P. Carkeek family.)

Four

WEBB'S WORLD

Webb Moffett was a well-known figure in the Pacific Northwest snow sports industry. A civil engineer, he erected rope tows at several local ski areas and took over management of the Snoqualmie Pass rope tow on Municipal Hill. He bought out the owners of the Snoqualmie Summit ski operation, Ski Lifts, shortly before World War II. In later years, Moffett increased his holdings to include the three adjacent ski areas—Ski Acres, Alpental, and Hyak—and remained active in his family's business until 1996, when the operation was sold to Booth Creek Resorts. Moffett was inducted into the Northwest Ski Hall of Fame in 1992 and the National Ski Hall of Fame in 1999. (Courtesy Webb Moffett family.)

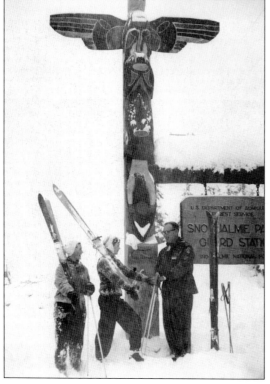

This 1948 image shows the old ranger's house at Municipal Hill, with the Hamburger Hut barely visible behind the trees. Virginia Moffett wrote about the early years she and her husband managed the ski resort: "During the war years, in the early 40s, the trend to skiing increased. Soldiers' lessons prevailed, and we put in one rope tow after another, also the Hamburger Hut, 150-feet long by 20-feet wide. Then, in the late '40s and early '50s, the boom began." (Courtesy Webb Moffett family.)

A totem pole stood in front of the old ranger's house at Snoqualmie Summit, pictured here in the mid-1950s. (Courtesy Webb Moffett family.)

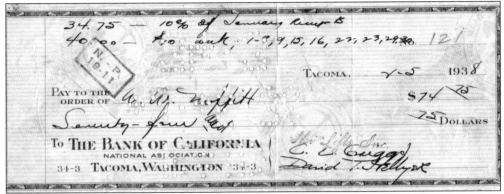

When the Moffetts first began managing the Snoqualmie Summit ski area in 1938, they received $10 a week from Ski Lifts and 10 percent of the January proceeds ($34.75). Their first paycheck came to a grand total of $74.75, which looked good to them at the time, considering they were young and poor. (Courtesy Webb Moffett family.)

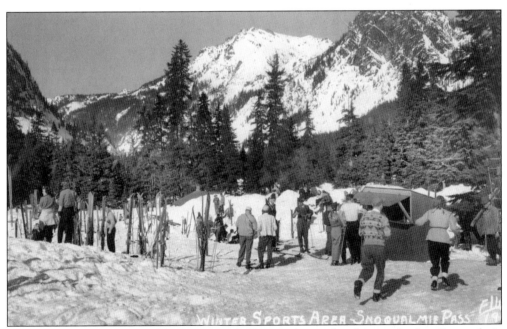

The hot dog stand, operated by Virginia Moffett on the weekends, was the first Snoqualmie ski area food concession. It also sold coffee, goggles, bootlaces, and ski wax. (Courtesy Webb Moffett family.)

"Old Betsy" was the first rope tow installed at the Snoqualmie Summit ski area. (Courtesy Webb Moffett family.)

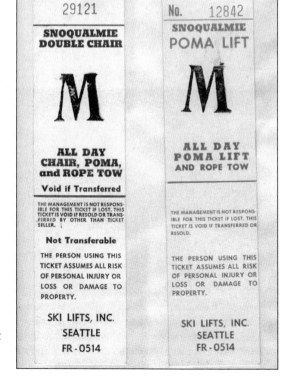

29121	No. 12842
SNOQUALMIE DOUBLE CHAIR	**SNOQUALMIE POMA LIFT**
M	**M**
ALL DAY CHAIR, POMA, and ROPE TOW	**ALL DAY POMA LIFT AND ROPE TOW**
Void if Transferred	
THE MANAGEMENT IS NOT RESPONSIBLE FOR THIS TICKET IF LOST. THIS TICKET IS VOID IF RESOLD OR TRANSFERRED BY OTHER THAN TICKET SELLER.	THE MANAGEMENT IS NOT RESPONSIBLE FOR THIS TICKET IF LOST. THIS TICKET IS VOID IF TRANSFERRED OR RESOLD.
Not Transferable	
THE PERSON USING THIS TICKET ASSUMES ALL RISK OF PERSONAL INJURY OR LOSS OR DAMAGE TO PROPERTY.	THE PERSON USING THIS TICKET ASSUMES ALL RISK OF PERSONAL INJURY OR LOSS OR DAMAGE TO PROPERTY.
SKI LIFTS, INC. SEATTLE FR - 0514	**SKI LIFTS, INC. SEATTLE FR - 0514**

Webb Moffett's home phone number was printed at the bottom of early Poma lift tickets, showing his personal commitment to customer service. (Courtesy Webb Moffett family.)

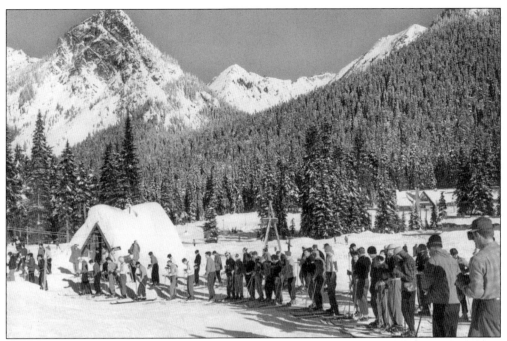

The lines of skiers waiting to ride the Poma lift at Snoqualmie Summit were often extremely long. In 1964, a second chair lift and two Poma lifts were added, and the skiable area was increased to 200 acres by clearing and grooming. (Courtesy Webb Moffett family.)

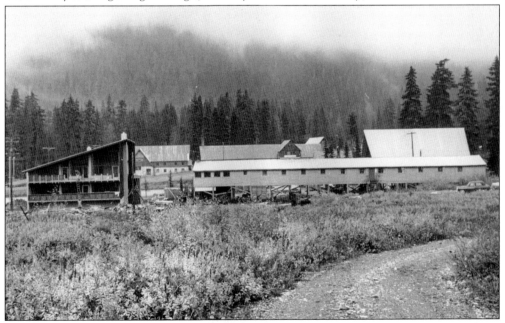

The old Hamburger Hut, erected during World War II, was torn down after the Swiss-modern-style Alpen Haus Lodge was built at Snoqualmie Summit in 1963. With no lumber available during the war years, Webb Moffett acquired an old Civilian Conservation Corps building and transported it in pieces to the Pass, where it took on a new life as the food concession building. (Courtesy Webb Moffett family.)

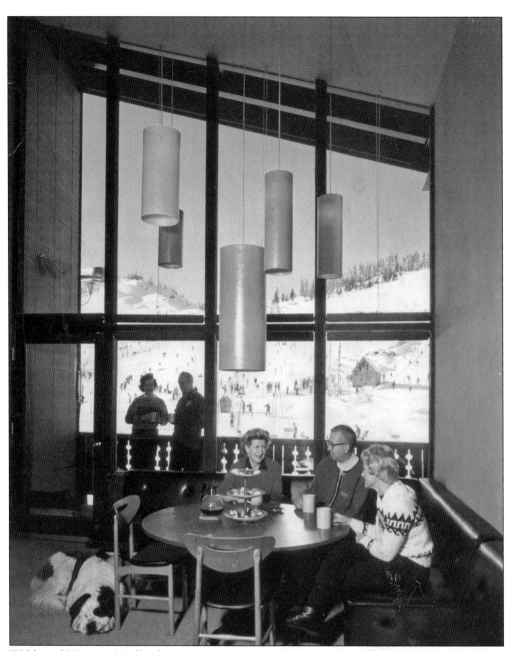

Webb and Virginia Moffett kept an apartment on the west side of the Alpen Haus Lodge at Snoqualmie Summit. Built in 1963, their weekend home on the slopes had circular stairs leading up to a balcony bedroom, and a compact kitchen. Designer Irene McGowan created the hanging yellow, orange, and gold lanterns. Jean Bullard (left) joins the Moffetts at their teak dining room table while the family's St. Bernard, Heidi, catches 40 winks on the floor. (Courtesy Webb Moffett family.)

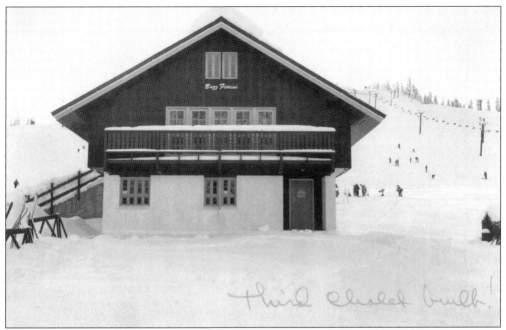

The third chalet built at the Snoqualmie Summit ski area housed the Buzz Fiorini Ski School. (Courtesy Webb Moffett family.)

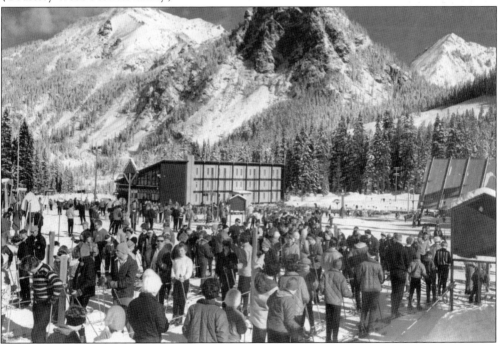

During the 1973–1974 ski season, with a nationwide energy crisis in full swing, Webb Moffett worked on a 10-percent cutback in electric consumption at Snoqualmie Summit. He accomplished this not by eliminating night skiing, but by shutting down various chair lifts when attendance was light. One chair lift drew more current in a single day than all the lights on the ski hill drew in a month. (Courtesy Webb Moffett family.)

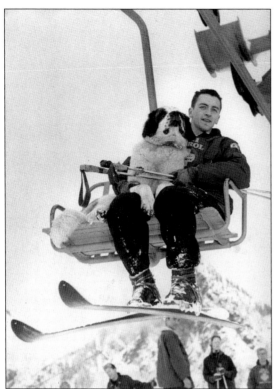

Don Ostrem of the Snoqualmie Pass Ski Patrol frequently rode the chair lift to the Thunderbird Restaurant with his St. Bernard, Corky, shown here in 1959. Corky served as an official greeter and tidbit-taker at the restaurant until Ostrem was ready to go home at the end of the day. (Courtesy Webb Moffett family.)

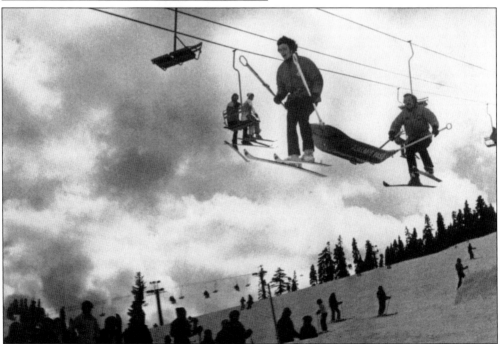

In the late 1970s, ski patrol members Dave Bankson (left) and his brother Don display their skill with a rescue toboggan as they drop from the chair lift to the slope below. (Courtesy Webb Moffett family.)

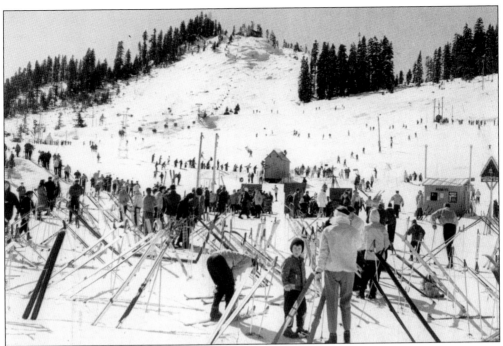

The Snoqualmie Summit ski area, with the Thunderbird chair lift and ski run in the background, is pictured on a busy weekend day. Before ski racks were installed near the Alpen Haus Lodge, skiers propped their skis and poles in the snow. (Courtesy Webb Moffett family.)

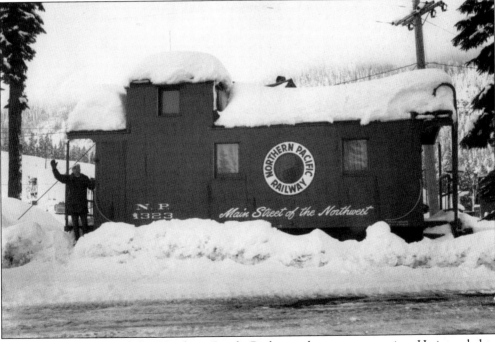

Webb Moffett purchased this Northern Pacific Railway caboose at an auction. He intended to turn it into a Snoqualmie Pass ski area museum. The dream was never realized, and the caboose was later sold to a private party. (Courtesy Webb Moffett family.)

The Continental Restaurant in the Alpen Haus Lodge first opened at the summit in March 1963. The restaurant included a coffee bar, dining room, and banquet room and served both continental and American-style dinners. Virginia Moffett professed it to be "the finest dining room between Seattle and Ellensburg." In later years, the restaurant was known as Webb's and became a favorite with Pass area residents. (Courtesy Webb Moffett family.)

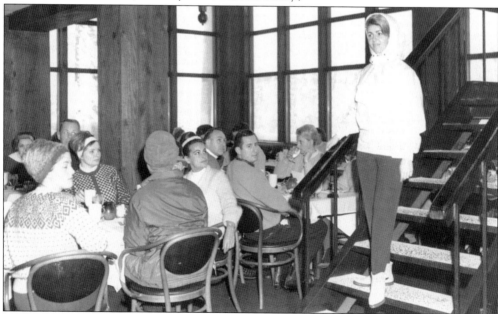

In the 1960s, the trend was toward sleek and attractive ski clothing, including stretch pants and parkas or matching short jackets. Ski fashion shows were common at the Continental Restaurant in the Alpen Haus Lodge, and models displayed elegant items like Dior creations and fur coats, made possible by Virginia Moffett's position as a fashion buyer for the Bon Marche. The Continental Restaurant provided plush nightclub-style surroundings and an alpine ambience aided by the thickly accented narration of Gunter Mittermeir of Munich, Germany. (Courtesy Webb Moffett family.)

From Switzerland...the Fondues

BOEUF BOURGUIGNONNE

Famed specialty of the house

in a pot on your fondue stove you plunge tender cubes of steak for a few seconds. Then, cooked to perfection, you dip the beef into a variety of tempting condiments. A half pound of choice steak, green salad, French fries.

$3.95

FROMAGE FONDUE A LA SUISSE

Served in every famous ski resort . . . the crusty chunks of French bread which you dip into the creamy, hot fondue of imported cheese and wine . . . touched with Kirsch brandy. Served with crisp green salad and your choice of dressing.

$2.50

for two $4.75

From our Native Land and From France

NEW YORK STEAK

Succulently thick steak . . . a generous ten ounce cut, char-broiled to your order and topped with maitre d'hotel butter and mushrooms.

$4.75

CHOPPED STEAK

All American favorite a half pound of choice chopped beef, broiled and topped with maitre d'hotel butter.

$2.50

BROILED LOBSTER

Flavourful, broiled lobster with hot, drawn butter, served a la Continental.

$4.95

SKIHAUS STEAK

Thick, eight ounces, juicy cut of choice sirloin, broiled to your wish and topped with maitre d'hotel butter.

$3.25

POULET SUSETTE

Delicious pieces of chicken breast in a rich sauce . . . touched with a breath of fresh ginger . . . rolled in thin French pancakes . . . topped with sauce and parmesan cheese . . . then broiled to perfection.

$2.95

CHILD'S PORTION

(Under 12 years of age)

Chopped Steak Dinner$1.25

Prawn Dinner ..$1.25

Hamburger served with French
 fries and salad$1.00

Served with the above meals: Crisp green salar, choice of dressing, French fries (or, after 5 o'clock baked Idaho potato); oven baked buttered French bread and onion rings.

The Continental Restaurant was known for its European-style boeuf bourguignonne fondue. The secret to its success, according to Virginia Moffett, was the "gleep"—a combination of different oils and melted butter. (Courtesy Webb Moffett family.)

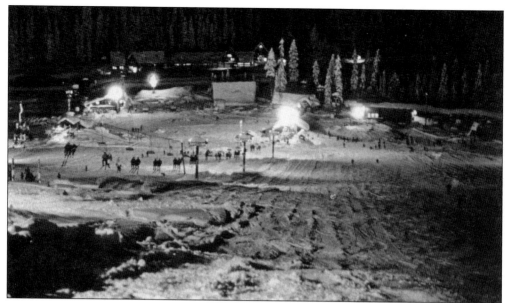

Snoqualmie Summit has been deemed "Night Skiing Capital of the World." In the early 1970s, Webb Moffett installed old gas station lights on the slope so his employees could ski after customers had gone home. With the ski resort only an hour's drive from the Seattle metropolitan area, night skiing quickly became popular and attracted thousands of participants, many of whom claimed they could see slope contours better under the mercury vapor lamps. Nighttime ski schools also began operation and offered complete ski packages, including transportation. (Courtesy Webb Moffett family.)

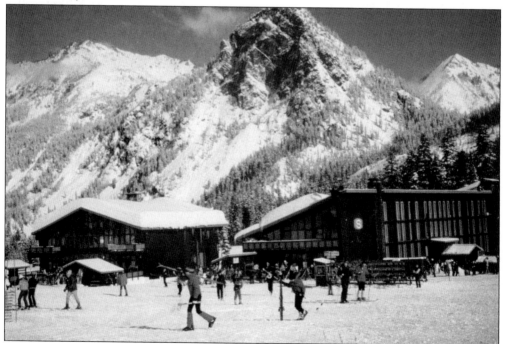

The Slide In Lodge, to the left of the Alpen Haus, was added to the Snoqualmie ski area in the late 1960s. (Courtesy Webb Moffett family.)

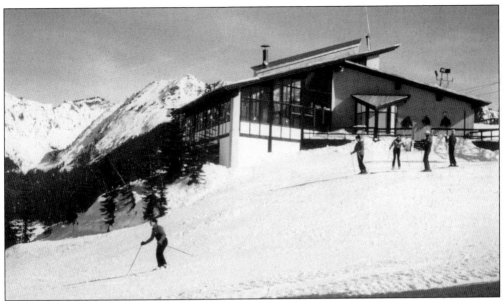

In 1954, the Thunderbird Lodge and chair lift were built in the area later known as Summit West. The striking lodge, designed by Seattle architects Tucker and Shields, was the pride and joy of ski area owners Webb and Virginia Moffett. Formed from two intersecting triangles, the building was set on concrete piers to keep it above the annual 20-foot snowfalls. On the outside wall facing the slope, a large Thunderbird motif was painted on the orange-stained cedar. (Courtesy Webb Moffett family.)

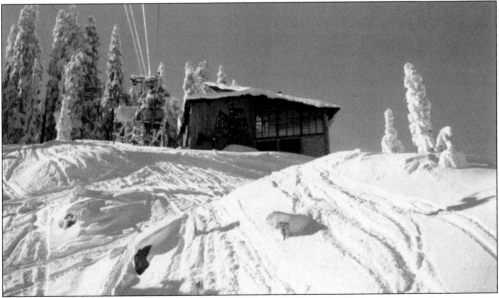

Perched high above the main ski area, the new Thunderbird Lodge lent an air of sophistication to Snoqualmie Summit. The post–World War II years brought rapid growth to ski resorts across the nation. Resort owners added flashy new buildings, comfortable chair lifts, and other amenities to attract skiers. Visitors delighted in the ride up the "T-bird" chair to the dramatic new lodge, where they could enjoy a meal with a scenic view or a cup of cocoa by the stylish fireplace. (Courtesy Webb Moffett family.)

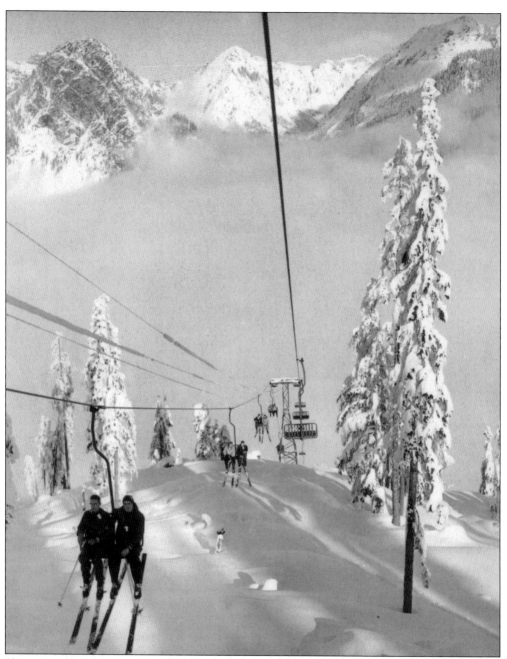

Ski area employees often rode the Thunderbird chair lift in the early morning to enjoy a few runs before the day's work began. Rising above the early morning fog on the left in the background is Guye Peak. (Courtesy Webb Moffett family.)

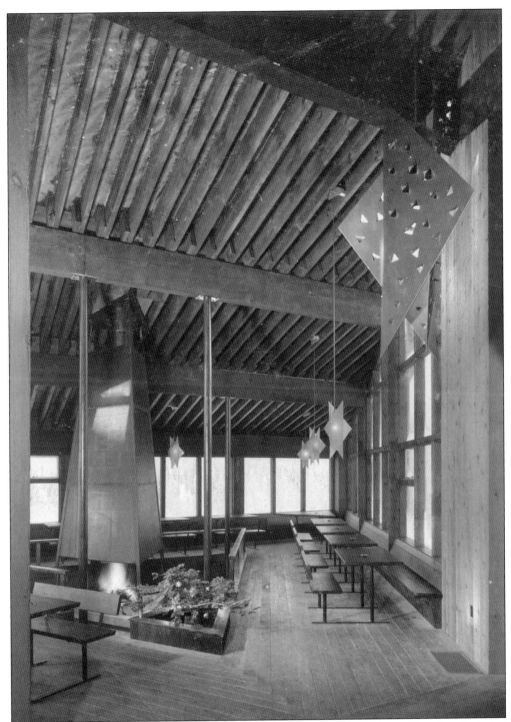

Special attention was given to the modern interior of the Thunderbird Lodge. The décor included massive stonework, Native American murals, a charcoal broiler, sunken triangular fireplace, gift shop, and walls of glass through which visitors could enjoy expansive views of the surrounding Cascade Mountains. (Courtesy Webb Moffett family.)

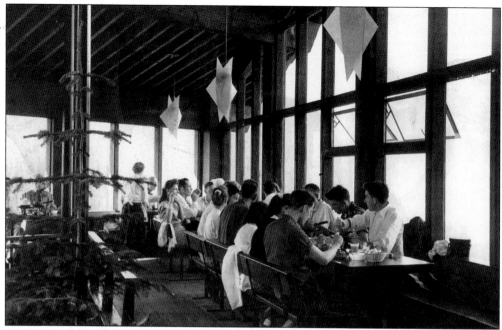

The menu at the Thunderbird Restaurant included an alpine breakfast, "Thunderburgers," and "Snoqualmie Deep Dish Apple Pie," among other items. A popular selection was the boeuf fondue, which was also served at the Continental Restaurant in the Alpen Haus Lodge. Faced with the problem of no running water in the Thunderbird Restaurant, the Moffetts searched for foods that could easily be served on disposable plates. (Courtesy Webb Moffett family.)

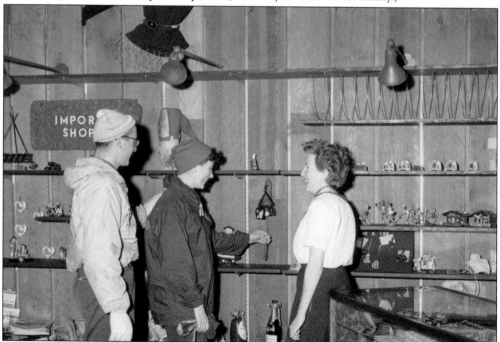

Visitors to the Thunderbird Lodge Import Gift Shop peruse alpine-style trinkets and clothing with the help of a resort employee. (Courtesy Webb Moffett family.)

David Moffett's senior class at Garfield High School in Seattle enjoyed a real treat when a party was held at the Thunderbird Lodge atop Snoqualmie Summit. David's parents, Webb and Virginia Moffett, provided the facilities and also catered the affair. On Sunday, May 1, 1960, the *Seattle Times* reported on the "Teen-Agers' Party on a Mountaintop," calling it a "really unusual" semiformal event. (Courtesy Webb Moffett family.)

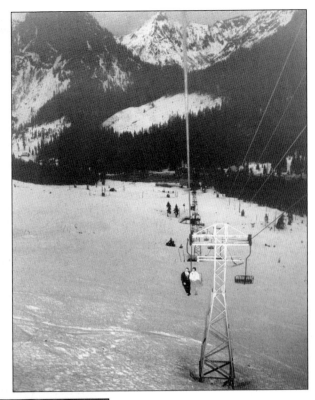

Garfield High School seniors Norman Winton and Susan Sprague (right) greet Frank Meyer and Barbara Campbell as they complete the 12-minute chair lift ride from the bottom of the ski hill. About 30 couples attended the party at the Thunderbird Lodge, and many of them had gone skiing earlier in the day. Dinner included boeuf fondue followed by dancing, but a number of couples spent a lot of time around the huge triangular fireplace, just enjoying the view and each other's company. David Moffett's date for the evening was Nancy Reynolds. (Courtesy Webb Moffett family.)

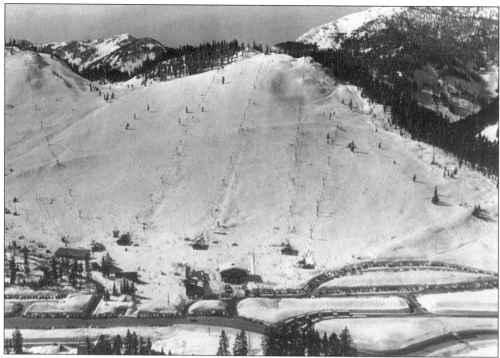

Snoqualmie Summit is seen in its entirety in this westward view from the 1970s. (Courtesy Webb Moffett family.)

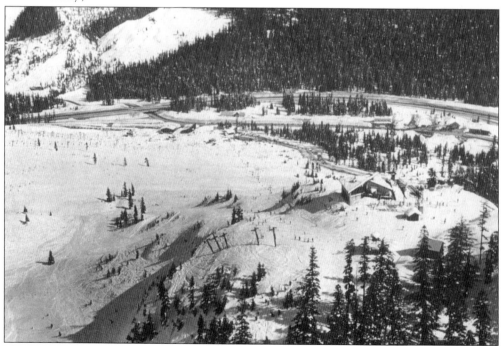

This expansive view shows the Beaver Lake area, which was the site of early ski-jumping tournaments beginning in 1929. Beyond the Thunderbird Lodge, U.S. Highway No. 10 runs at the base of the hill. (Courtesy Webb Moffett family.)

Andre Hirsch and Lenore Lyle reign as king and queen of the mountain during a Snoqualmie Summit Spring Carnival around 1967. Activities at the annual two-day Spring Carnival included skydiver demonstrations, a battle of the bands, a dance on snow, a scavenger hunt, baseball on short skis, races, clowns, a torchlight parade, and the crowning of royalty. Carnival queen and ski instructor Lenore Lyle later became the owner of Ski Masters Ski School. She also served as the president of the Professional Ski Instructors of America–Northwest, making her one (of two) of the first women divisional presidents. (Courtesy Webb Moffett family.)

In January 1974, David and Susan Moffett enjoy festivities at the dedication of Julie's Chair, along with honoree Julie Fiorini (center). The Thiokol double beginner chair lift at Snoqualmie Summit cost $140,000 and was illuminated for night skiing for another $20,000. Buzz and Julie Fiorini, Northwest ski legends, owned and operated Fiorini Ski School at the summit, as well as a popular retail ski shop in Seattle. Both were certified ski instructors and were inducted into the Northwest Ski Hall of Fame in 1996. (Courtesy Webb Moffett family.)

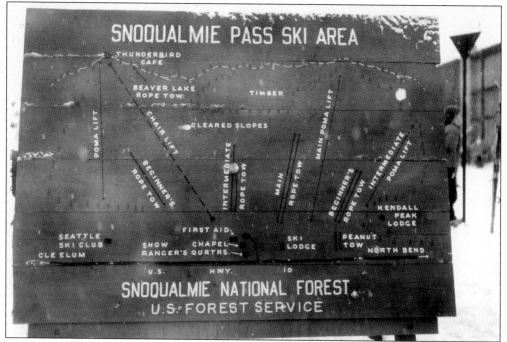

The U.S. Forest Service installed this wooden sign at the base of the Snoqualmie ski area. For several years, it helped visitors to identify the locations of ski runs and buildings. (Courtesy Webb Moffett family.)

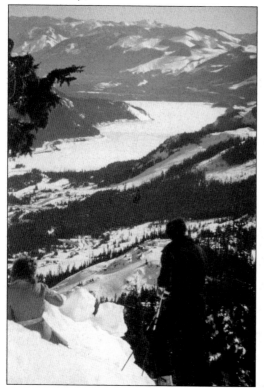

Two skiers at the top of Alpental's Upper International ski run stop to take in a spectacular view. After dismounting Chair Two, a short hike uphill reveals a vista of the entire Snoqualmie Pass area, including the ski resorts, Lake Keechelus, and Washington State icon Mount Rainier to the south. (Courtesy Webb Moffett family.)

Five

THE GOLDEN GIRL

Seattle's own Deb Armstrong, currently the ambassador of skiing for Taos Ski Valley, New Mexico, is best known for winning the gold medal in giant slalom at the 1984 Winter Olympic Games in Sarajevo, Yugoslavia. It was the first American gold medal in skiing in 30 years and the 1,000th gold medal awarded to an American athlete in Olympic competition. Armstrong's home training grounds were at Alpental Ski Resort in Snoqualmie Pass. Her exceptional accomplishment at age 20 inspired many Northwest skiers and sports enthusiasts to achieve their own personal best. (Courtesy Hugh and Dollie Armstrong.)

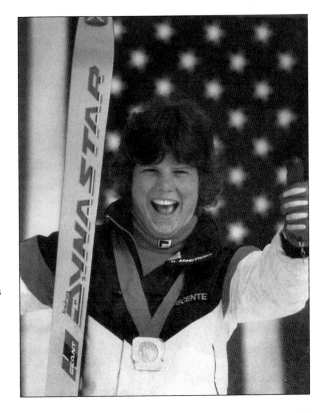

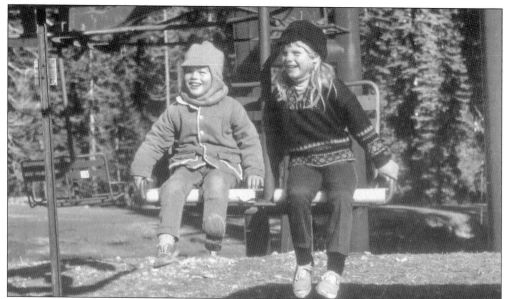

Deb Armstrong (right), age five, and her brother Olin Armstrong, age three, rest on a chair lift after an autumn hike. The future gold medallist began skiing at Alpental when she was three years old. Both Deb and Olin were members of the Alpental Mighty Mites, a ski racing team for children. They later joined the Alpental team and represented the Northwest Division of the United States Association in junior races. (Courtesy Hugh and Dollie Armstrong.)

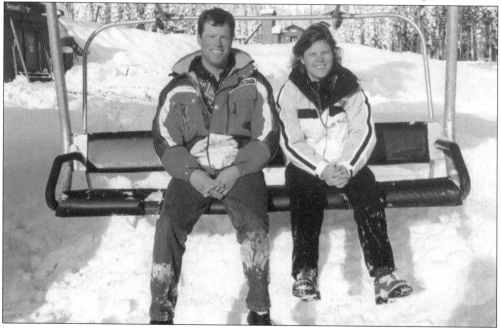

About 30 years after the previous photograph, Olin Armstrong (left) and Deb Armstrong are pictured at the dedication of the Armstrong Express chair lift at Alpental in 1998. Olin Armstrong raced for 10 years. He has also coached for Team Breckenridge in Breckenridge, Colorado; for the U.S. Ski Team; and for the B and C teams on the Europa Cup circuit. (Courtesy Hugh and Dollie Armstrong.)

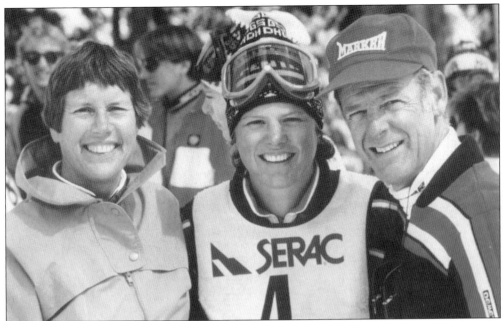

Hugh (right) and Dollie Armstrong (left) regularly attended races, such as this one at Alpental in 1981, to cheer for their daughter, Deb. Hugh Armstrong, a clinical psychologist at the University of Washington, served as technical director of the Alpental ski school for many years and as a sports psychologist consultant to the U.S. Ski Team. Dollie Armstrong, a teacher, was a supervisor and trainer at the Alpental ski school. Both volunteered in many capacities for the SKIFORALL Foundation, helping it grow into one of the largest outdoor recreation programs in the world for people with disabilities. (Courtesy Hugh and Dollie Armstrong.)

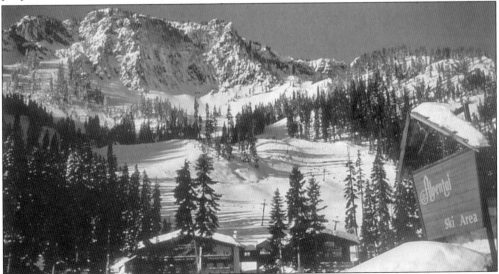

Alpental Ski Resort, situated at the northern end of Snoqualmie Pass, is approached through a three-sided canyon bordered by Denny Mountain, Mount Snoqualmie, and Guye Peak. After beginning operations during the 1967–1968 ski season, Alpental became a popular winter recreation destination for many Seattle-area residents, including the Armstrong family. (Courtesy Hugh and Dollie Armstrong.)

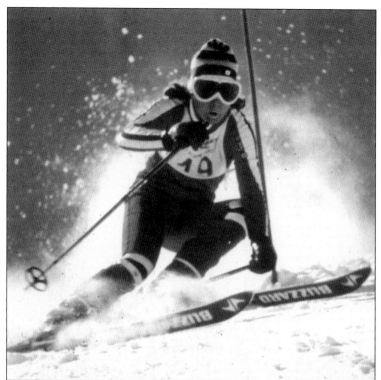

Deb Armstrong was a member of the Alpental race team from 1977 to 1981. The team's official cap bore a bumblebee design. (Courtesy Hugh and Dollie Armstrong.)

In 1981, the same year Deb Armstrong graduated from Garfield High School in Seattle, she won the U.S. Junior National Giant Slalom Championship at Squaw Valley, California, and was named to the U.S. Alpine Ski Team. A self-proclaimed jock, Armstrong preferred to keep active in all sports rather than specialize; too short for basketball, she skied instead. (Courtesy Hugh and Dollie Armstrong.)

Deb Armstrong wears her gold medal while standing on the Olympic podium at the 1984 Winter Games in Sarajevo, Yugoslavia. Going into the Olympics, Armstrong's goal was to "experience the uniqueness of Olympic competition." This attitude helped her stay in the moment and have fun without excessive worries about the outcome. After eight years on the World Cup circuit, Deb Armstrong retired in 1988. (Courtesy Hugh and Dollie Armstrong.)

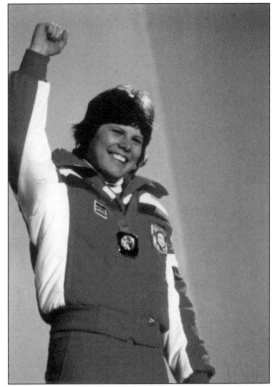

For many years, Alpental was the weekend destination of the Armstrong family. From left to right, Olin, Dollie, Hugh, and Deb Armstrong, together in this 1983 photograph, had years of fun engaging in snow sports. Their involvement in racing, teaching, and supervising led to careers in the ski industry for each of them. (Courtesy Hugh and Dollie Armstrong.)

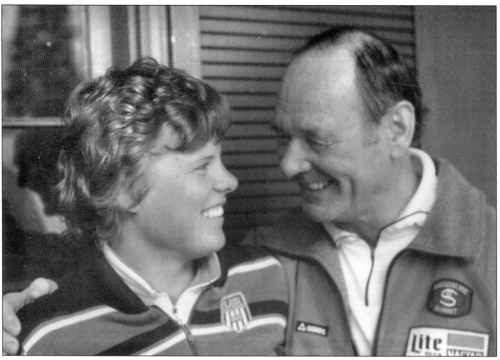

Deb Armstrong shares a happy moment with Adi Hienzsch, supervisor of Alpental's resident ski school, in the 1980s. (Courtesy Adi and Eva Hienzsch.)

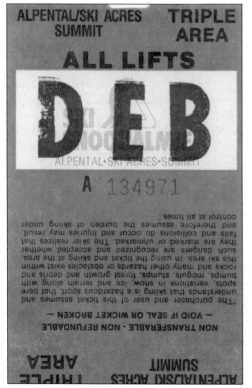

During the opening of the 1984–1985 season, all of Snoqualmie Pass was rippling with excitement because a local-based skier had claimed a gold medal during the Winter Olympics. On the day an Alpental chair lift was dedicated in Deb Armstrong's honor, all lift tickets proudly displayed a special code: DEB. (Courtesy Hugh and Dollie Armstrong.)

Debbie's Gold, a double chair lift, was named in honor of the gold medal Deb Armstrong had won earlier that year in Sarajevo. (Courtesy Hugh and Dollie Armstrong.)

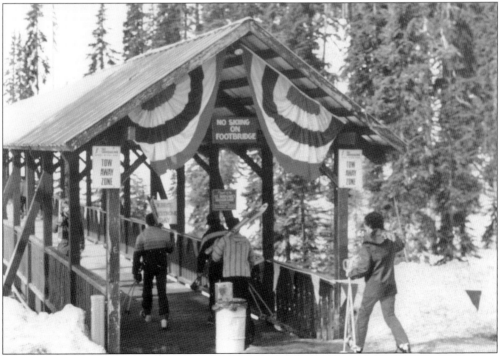

The footbridge leading from the Alpental parking lot to the ski resort is festooned for the opening day of ski season in 1984. (Courtesy Hugh and Dollie Armstrong.)

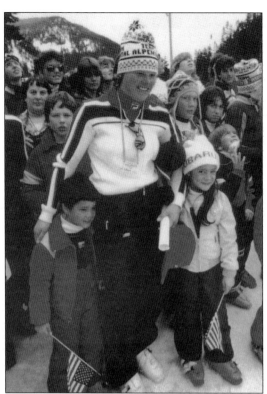

At the Debbie's Gold dedication ceremony, Deb Armstrong enjoys the company of young friends Genia De Cano (right) and Jeremy Thompson (left). (Courtesy Hugh and Dollie Armstrong.)

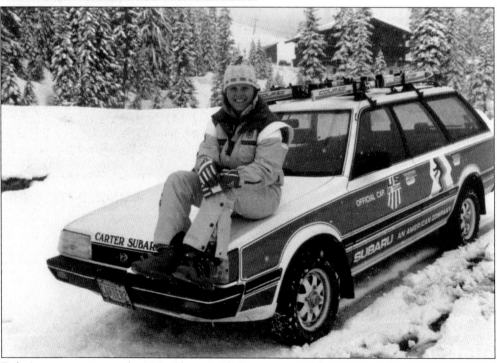

Deb Armstrong sits on the U.S. Olympic Ski Team car, a Subaru wagon. (Courtesy Hugh and Dollie Armstrong.)

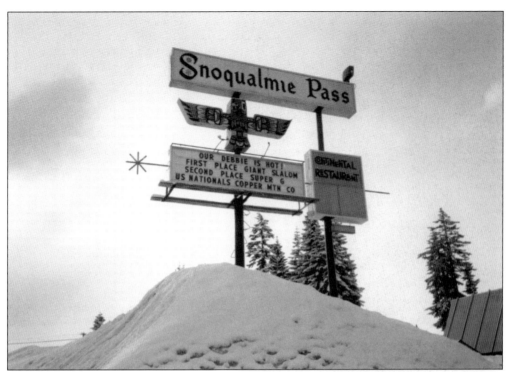

The old Thunderbird sign in front of the Alpen Haus at Summit West was a sentimental landmark for Pass residents, employees, and visitors. The structure was taken down when the Moffett family sold the ski resort to Booth Creek Resorts in the mid-1990s. On the day this photograph was taken, Snoqualmie Summit's reader board displayed "Our Debbie is Hot!" (Courtesy Hugh and Dollie Armstrong.)

Webb Moffett, owner of the Snoqualmie ski area, is shown with Deb Armstrong in 1983. (Courtesy Hugh and Dollie Armstrong.)

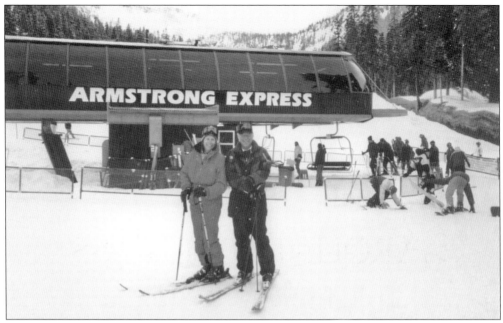

On November 14, 1998, a high-speed quad chair lift replaced Debbie's Gold. The new chair lift was named the Armstrong Express in honor of the entire family. The ski run retained the name of Debbie's Gold. Shown are Dollie Armstrong (left) and Hugh Armstrong (right). (Courtesy Hugh and Dollie Armstrong.)

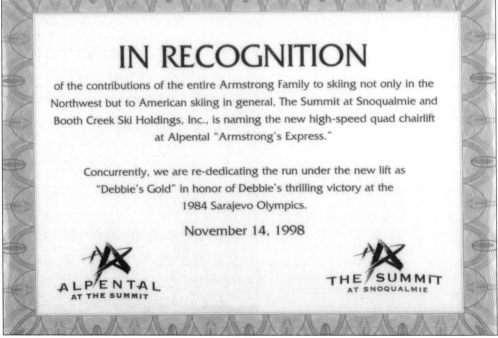

IN RECOGNITION

of the contributions of the entire Armstrong Family to skiing not only in the Northwest but to American skiing in general, The Summit at Snoqualmie and Booth Creek Ski Holdings, Inc., is naming the new high-speed quad chairlift at Alpental "Armstrong's Express."

Concurrently, we are re-dedicating the run under the new lift as "Debbie's Gold" in honor of Debbie's thrilling victory at the 1984 Sarajevo Olympics.

November 14, 1998

ALPENTAL
AT THE SUMMIT

THE SUMMIT
AT SNOQUALMIE

At the dedication of the Armstrong Express chair lift, a certificate of appreciation was given to the Armstrong family in recognition of its many contributions to the sport of skiing, both in the Northwest and across the country. (Courtesy Hugh and Dollie Armstrong.)

Six

AROUND THE PASS

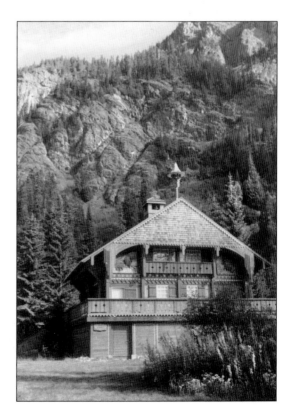

The geographic features of Alpental
(German for "alpine valley") at
Snoqualmie Pass inspired community
developers to create a little bit of
Europe in the heart of the Cascade
Mountains. Alpental residents formed
a community club and agreed to bylaws
in order to maintain symmetry with the
environment. Rising from the valley
floor behind the chalet is Guye Peak, its
lower slopes resplendent each autumn
with brilliant red and orange vine maples
and huckleberry bushes. (Courtesy
the authors.)

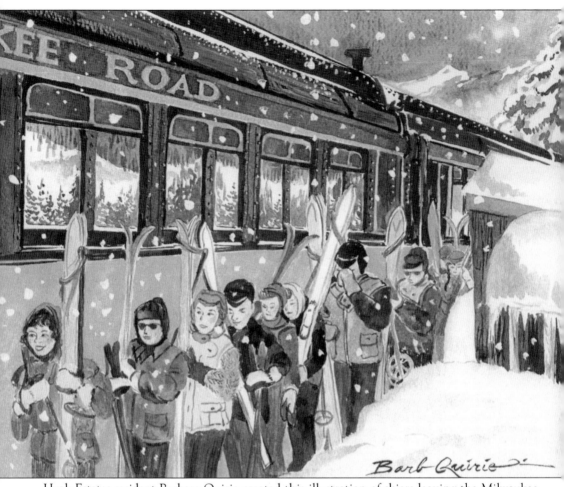

Hyak Estates resident Barbara Quirie created this illustration of skiers leaving the Milwaukee Railway ski train in 1939. (Courtesy Ed and Barbara Quirie.)

Hank Cramer (pictured) and Steve Akerman, who performed together as part of the Rounders, entertained at Alpental for the first Music in the Mountains summertime concert series in 2001. Sponsored by the Summit at Snoqualmie, the Snoqualmie Pass Women's Group, and other organizations and individuals, the annual music festival was off to a rousing start. Cramer, a traveling folk singer based in the Methow Valley, is known for his powerful bass voice and incredible repertoire of songs about cowboys, sailors, soldiers, miners, drifters, trains, and other subjects, all of which weave together music, history, and cultural traditions. (Courtesy Hank and Kit Cramer.)

Thomas Tilton, dressed in Austrian folk costume, catches the attention of Alpental skiers by blowing an alphorn. Made from wood with a conical bore, the alphorn was traditionally used as a signal instrument by mountain dwellers in Switzerland and across the Alps. Tilton, a local high school counselor, performed at Snoqualmie Pass on a regular basis. (Courtesy Hugh and Dollie Armstrong.)

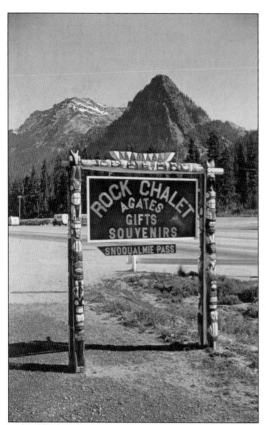

The Rock Chalet, a well-known institution at Snoqualmie Pass, was a popular tourist stop for many decades. Jack and Wilma Preston opened the gift shop in 1948 and retired after 40 years. In August 1987, a large number of Pass homeowners and friends gathered to honor the couple's contributions and see them presented with a plaque carved by local artist Adi Hienzsch. (Courtesy the authors.)

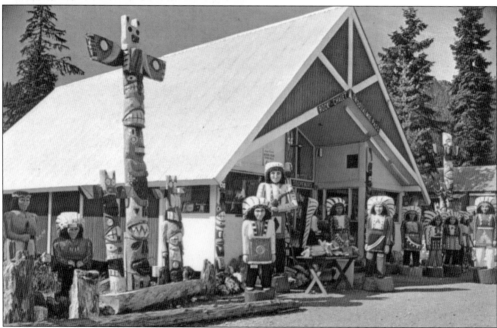

Colorful totem poles and carved Native American sculptures attracted passing motorists to the Rock Chalet. (Courtesy the authors.)

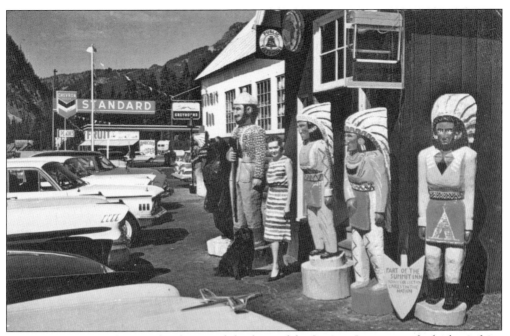

Native American sculptures also decorated the front of the Summit Inn, across the highway from the Rock Chalet. Jack and Wilma Preston operated the old Summit Inn when the Rock Chalet was built. (Courtesy the authors.)

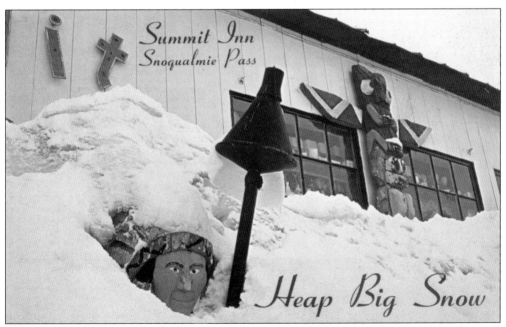

"Chief Big Snow" was a member of the Summit Inn's world-famous collection of wood-carved Native Americans. In this old postcard, he appears a little frostbitten, nearly buried by snow that has been thrown from U.S. 10 by rotary plows. (Courtesy Jack Leeper.)

The three-mile-long Alpental Valley at the northern end of Snoqualmie Pass was first developed in the mid-1960s. Preparation included the widening and extension of the road that led into the canyon from the summit area. The first bridge along Alpental Road was built near the Sahalie Ski Club. The original Sahalie Lodge burned down in 1943 and was replaced by a new lodge, with an addition constructed in the late 1960s. (Courtesy Adi and Eva Hienzsch.)

This is how Alpental Road appeared when it was first cleared. (Courtesy Adi and Eva Hienzsch.)

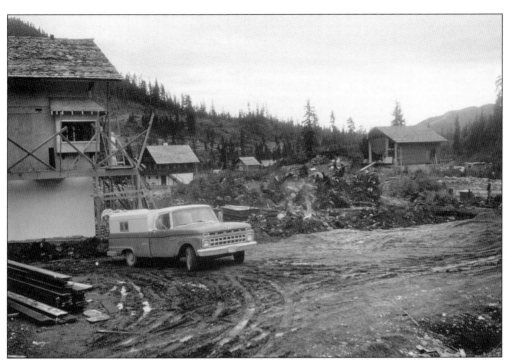

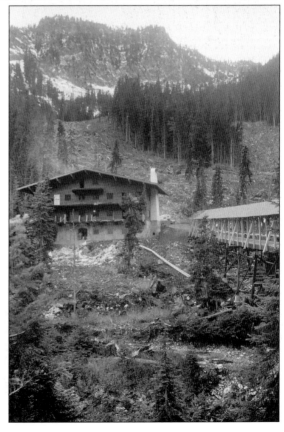

Multiple chalets on Alpental Strasse were constructed at the same time. A Tyrolean-Bavarian design was selected for the community. Basic building materials consist of stone, concrete block, and painted or whitewashed stucco, with brown-stained wood. Also prominent are gables, massive roof beams, and overhangs to protect balconies from heavy snowfall. Shutters, bell towers, flower boxes, wrought iron, and other embellishments provide finishing touches. (Courtesy Adi and Eva Hienzsch.)

The lodge at Alpental Ski Resort was also designed in the Tyrolean-Bavarian style. Before the start of ski season in November 2003, the bridge that led from the parking lot to the ski area collapsed overnight after a heavy rainfall. It was rebuilt just in time for opening day in November 2005. (Courtesy Adi and Eva Hienzsch.)

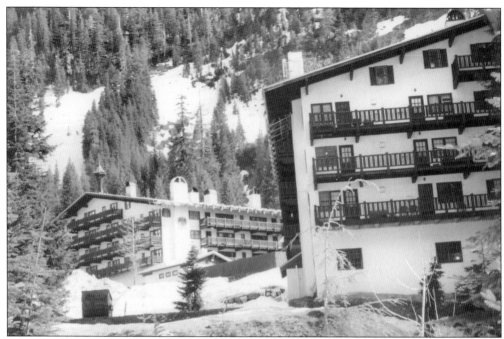

The Alpental Land Company planned condominium homes as part of a larger-scale development in the Alpental Valley. The Golden Adler and Golden Hirsch (above) contain 94 units altogether, with underground parking. The Alpenrose condominium complex (below) was built between the Alpental resort and the residential community. Initially the lodge complex was intended to serve as a valley sports and activity center with a year-round Olympic-size swimming pool, skating rink, tennis/curling courts, and a sauna and therapy room. An aerial tramway, never built, was planned from the valley to the saddle of Guye Peak, continuing with a chair lift to Snoqualmie Summit. A street of Austrian- and Swiss-style shops, called Alpental Strasse, was to have been connected by a covered walking bridge over the South Fork Snoqualmie River to the day lodge complex. Instead Alpental Strasse was developed as a residential street. (Courtesy the authors.)

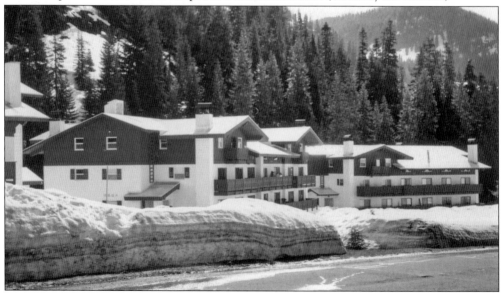

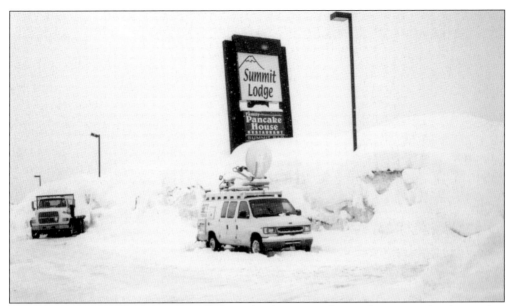

Snoqualmie Pass residents do not need to watch television to learn when winter has begun, but many Seattle-area residents awaiting snow sports season rely on media coverage. Each year at the winter season's first significant snowfall, television station vehicles park along the highway at Snoqualmie Summit. Reporters prepare weather and traffic updates at the scene, asking residents, business owners, and travelers to tell (one more time) how they manage in all that snow. (Courtesy the authors.)

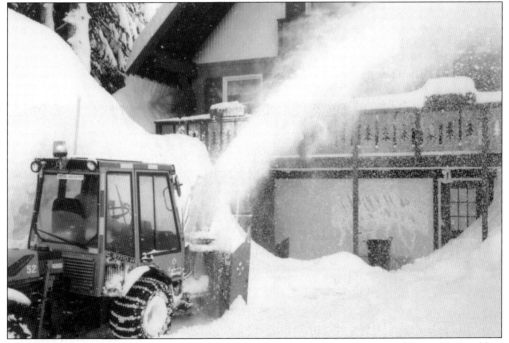

Viveca Mackner clears a residential driveway in time for the owner's return home. She and her husband, Pat Mackner, are contracted to do snow removal for the Alpental Community Club, in addition to many other areas at the Pass. (Courtesy the authors.)

After the old Summit Inn was demolished, a new one began construction in the 1970s. The existing gas station remained open until the property was completely developed, and then a modern service station was built. (Courtesy Steve White and DeAnna Reynolds.)

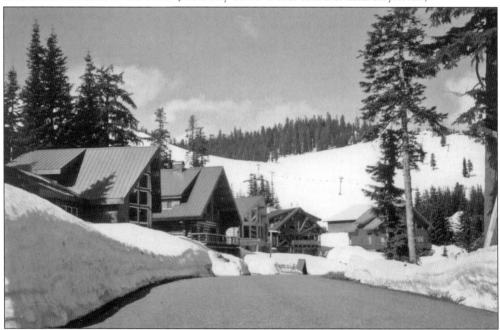

Village at the Summit homeowners can walk to the nearest ski lift, provided they can get over or through the snow berms in between. The Village, which consists mostly of large log homes, backs up to the slopes of Summit West. It was the last of the three main residential communities to be developed on the Pass. (Courtesy the authors.)

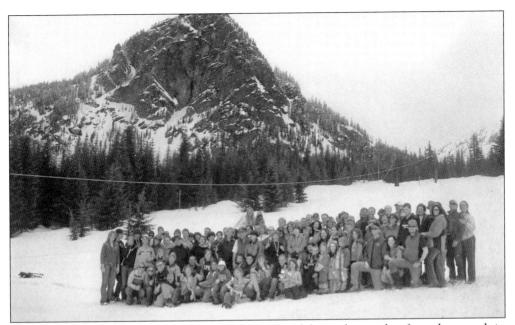

With imposing Guye Peak as a backdrop, Sahalie Ski Club members gather for a photograph in 2006. The Sahalie is one of many private ski clubs at the Pass, which over the years have included the Mountaineers, the Washington Alpine Club at Alpental, the Seattle Ski Club at the Summit, and the Continental Club at Hyak, among others. In the 1960s, the Sahalie Ski Club installed one of the longest private rope tows in the country. (Courtesy Linda Schrott.)

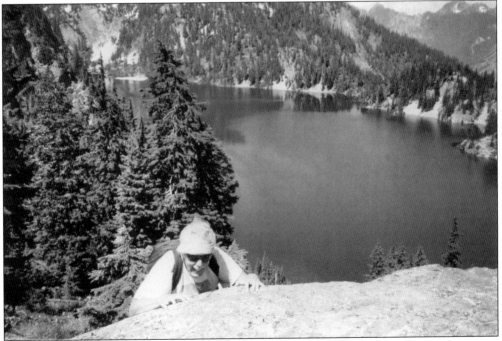

Rich Poelker, former president of the Sahalie Ski Club, scrambles over a ledge above Snow Lake, a popular hiking destination in the Alpine Lakes Wilderness recreation area. (Courtesy Rich Poelker.)

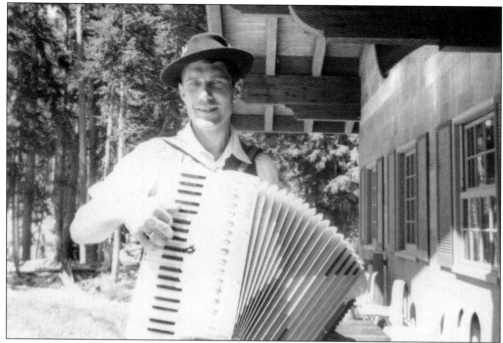

Alpental Ski Resort provided live music in the lodge on a steady basis during its early years of operation. This accordion player was a regular entertainer for many years. (Courtesy Hugh and Dollie Armstrong.)

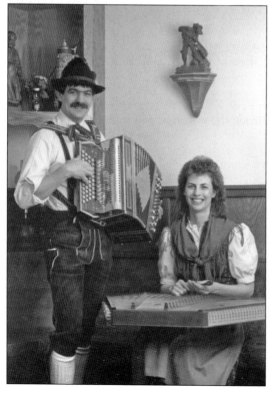

In 1987, Thomas Tilton and his wife, Corinne Pflug-Tilton, formed AlpenFolk, an Austrian-style folk music band. The group, which performs regularly in the Bavarian-style resort town of Leavenworth, Washington, provided entertainment at the Snoqualmie Pass Oktoberfest in October 2001. The combination of folk instruments such as a button accordion, hammered dulcimer, guitar, and bass with traditional vocals and yodeling added a genuine alpine touch to the celebration. (Courtesy Thomas Tilton.)

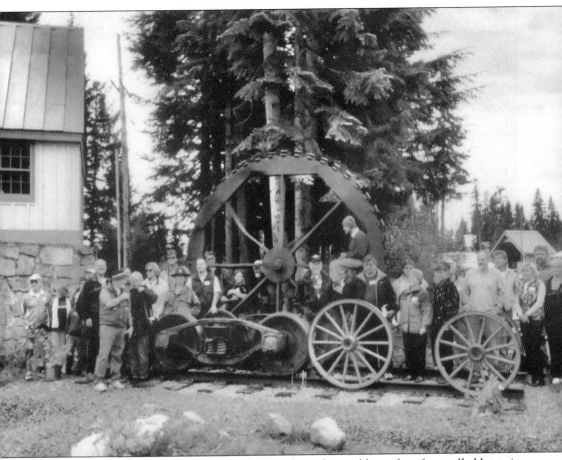

Ed and Barbara Quirie designed and built a large sculptural assemblage of artifacts called *Laconia* to commemorate the early railroad history of Snoqualmie Pass. The railroad trucks, made in 1935, were obtained from the Mount Rainier Scenic Railroad, and the large bull wheel was acquired locally. A wheelwright in Juliet, Montana, remade the wagon wheels from rims that traveled over the Pass in 1860. Many Snoqualmie Pass residents attended the dedication of the *Laconia* sculpture on November 18, 2003. From left to right are Einar Svensson, unidentified, Ed Quirie, Tom Meehan, Linda Legg, Maurya Broadsword, David Lockwood, Colleen Hawley (in ranger's hat), Chris Caviezel, Jim Elms, unidentified, Ken Quirie, Michael Murphy (sitting on bull wheel), Bill Kaffenberger, unidentified, Linda Kaffenberger, Barbara Quirie, Michael Uretz, Randy Daley, Sheri Kelly, Chris Everett, and two unidentified people. (Courtesy Ed and Barbara Quirie.)

The Chapel of St. Bernard at Snoqualmie Summit was designed by Tucker and Shields, the same architectural firm to create the Thunderbird Lodge. The interdenominational chapel began offering services in February 1960 when still unfinished and initially held seven half-hour services each Sunday. (Courtesy Ed and Barbara Quirie.)

Many weddings have occurred at the Chapel of St. Bernard. In September 1992, family and friends joined John and Chery Kinnick to witness their marriage. The assembled group includes the following, from left to right: (first row) Missy Waldren, Rebekah Gonzalez, Trevor Kinnick, Courtney Ward, and Alyssa Kinnick; (second row) Wendy McDaniel, Stephanie Bennett, Ian Ward, Tom Waldren (holding Kevin Waldren), Cathy Waldren, and Nicole Kinnick (with hat, holding Sherée Gonzalez); (third row) Nancy Ferman, Teresita Guerrero, Brian Carey, Carole Odegaard, Chery Kinnick, John Kinnick, Renee Gonzalez, Hilary Carman, and Robert Matheson. (Courtesy the authors.)

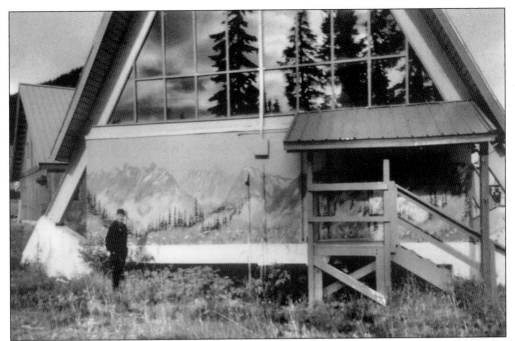

Barbara Quirie reveals the mural she designed for the back wall of the St. Bernard Chapel. Quirie asked her art students to help paint the scene, which depicts the nearby Gold Creek Valley. (Courtesy Ed and Barbara Quirie.)

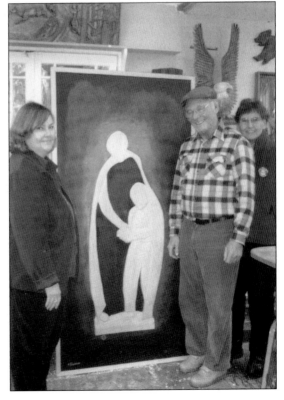

Adi and Eva Hienzsch (right) present a basswood carving of a teacher and child to St. Bernard Chapel director Sherry Pickett in February 2007. Adi Hienzsch has been a woodcarver and painter for over 50 years, and his commissioned sculptures can be found throughout the world. He also carved the name plaques for the Golden Adler and Golden Hirsch condominiums at Alpental. Now retired, Hienzsch works out of his Edelweiss Carving Studio in North Bend, Washington. (Courtesy David and Susan Black.)

David and Susan Black purchased the local *Snoqualmie Pass Times* newspaper from DeAnna Reynolds. Reynolds had started the publication in 1995 as a way to get area information out to the many visitors who stopped by the Traveler's Rest and Time Wise Grocery with questions. The Blacks built the newspaper, now called the *Cascade Times*, from a four-page monthly to a multi-paged weekly. Also owning and operating the Snoqualmie Pass Cable Company, the Blacks moved to Hyak Estates in 1992 after building their own home. (Courtesy David and Susan Black.)

Senior residents at Snoqualmie Pass insist that one need not be young to enjoy living in the mountains. From left to right, Tom Meehan, 85, Bob Kay, 76, Don Jeffery, 73, and Bruce Heacock, 72, agree that nearby outdoor recreation keeps them at the Pass. For Bob Kay, it is the alpine fishing in particular. A Pass resident since 1952, Kay often has to dig through heavy snow to gain access to his trailer. Don Jeffery is a longtime Denny Creek resident. Tom Meehan moved to the Denny Creek area in 1988, and Bruce Heacock has lived in Hyak since 1995. (Courtesy the authors.)

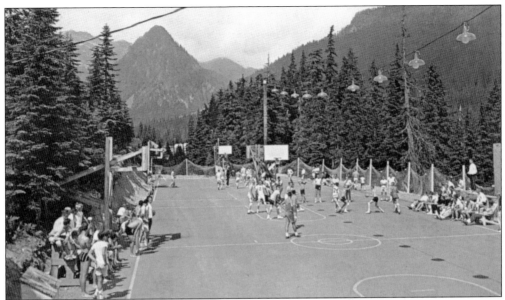

In 1960, Chuck Randall, Earlie McKie, and Ray Thacker created the Conifer Athletic Camp in the Conifer Estates section of Snoqualmie Pass. The camp provided intensified basketball training for athletes aged 12 through high school, and was one of the first basketball camps in the country. Presided over by experienced, successful coaches, the program included individual daily instruction and game experience for all participants. The camp operated for 14 seasons. (Courtesy Jack Leeper.)

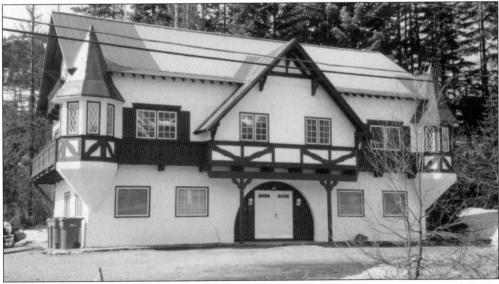

Pass residents refer to this Bavarian-style building in Hyak as the Castle. Built in the mid-1960s, it was intended to be the gateway to a large recreational development. When the development failed to materialize, the Castle became the Snoqualmie Pass Post Office. The building is currently a condominium complex. The Kittitas County residential community of Hyak Estates, located on the slopes above the Castle, has more full-time residents than any other area at the Pass. In 1992, Webb Moffett's company, Ski Lifts, purchased Hyak Ski Resort in bankruptcy court. (Courtesy the authors.)

Jack and Linda Price, operators of Happy Trails Horse Adventures in Easton, Washington, participated in the 10th anniversary Mountains to Sound March. To celebrate the accomplishments of a decade, the Greenway Trust hosted various events from July 13 to 22, 2000, including a 120-mile march over a 10-day period. The first three days, from Thorp to Snoqualmie Pass, were traveled by wagon train on the John Wayne Pioneer Trail in Iron Horse State Park. Here Sen. Slade Gordon speaks at Hyak Station from aboard Jack Price's wagon. (Courtesy Jack Price.)

A couple enjoys dancing to the country gospel and classic cowboy sound of Mended Heart. The Pacific Northwest–based band played at the opening of the replicated Hyak Railway Station during the Mountains to Sound celebrations of July 2000. (Courtesy Jack Price.)

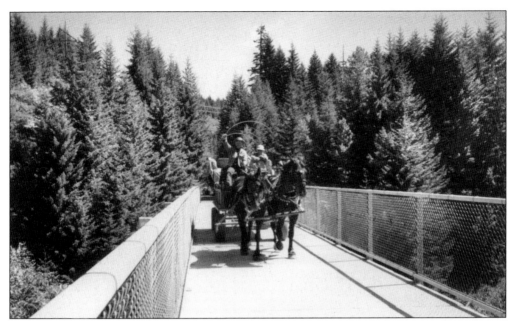

One of the goals adopted by the Mountains to Sound Greenway Trust was to repair the collapsed railway trestle along the old Milwaukee Railway, about 14 miles west of Snoqualmie Pass. The new bridge, erected at a cost of about $3 million, was necessary to provide continuous access for hikers and cyclists along the John Wayne Pioneer Trail. Before completion of the bridge, Happy Trails wagon train rides also made excursions into the Alpental Valley. (Courtesy Jack Price.)

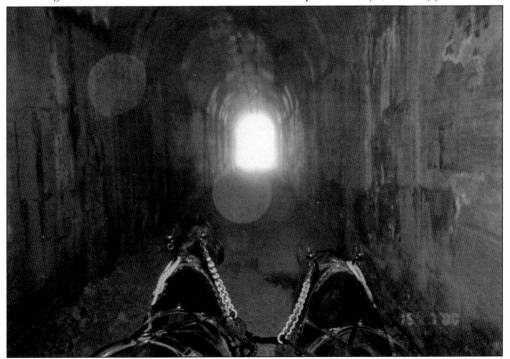

A Tunnel of Love horse-drawn wagon ride included a trip through the long and dark Milwaukee Railway tunnel at Snoqualmie Summit. (Courtesy Jack Price.)

An early owner of this chalet on Alpental Strasse commissioned a painting by local artist Linda Lee Foster. An outdoor enthusiast and ski instructor of over 30 years, Foster has indicated that over time her art has become "a meeting between the trees, earth, rain, snow and sun." She has won both national and international awards and has taught art courses for all levels of students, from novice to accomplished, in various King County locations. Her advice to art students is to "be happy where you are . . . then the window will open and you'll move to the next level—the next special thing." (Courtesy Linda Lee Foster.)

Linda Lee Foster also painted this likeness of the Sahalie Club ski hill and rope tow along Alpental Road. The beauty of the Snoqualmie Pass area has provided Foster with a wealth of inspiration over the years. (Courtesy Linda Lee Foster.)

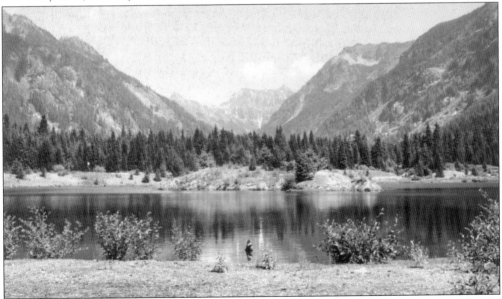

A cherished vista at Snoqualmie Pass is the view north from Gold Creek Valley to Chikamin Peak in the Alpine Wilderness area. Gold Creek in Kittitas County, the site of early prospecting and mining, was formed by the removal of gravel for the building of Interstate 90. Now a park, Gold Creek is of unequaled beauty, attracting many deer, elk, beaver, and migratory birds. Picnic tables and a paved walking trail surrounding the pond provide easy access so that visitors may enjoy the spectacular Cascade scenery. (Courtesy the authors.)

A gray jay, also called a whisky jack or camp robber, catches a few fleeting moments of rest on a rock outcropping high atop Guye Peak. (Courtesy Danny Miller.)

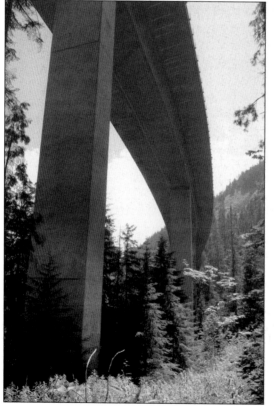

West of Snoqualmie Summit, Interstate 90 proceeds along a lengthy viaduct over the Denny Creek area. Although construction of the bridge began in 1972, it was delayed until the late 1970s due to lawsuits from environmental groups. The 200-foot-tall bridge was completed in 1981 for $13 million. Costs ran high because of the use of scaffolding that did not touch the ground in order to reduce impact on the surrounding environment. The viaduct allows westbound traffic to proceed without fear of avalanches from nearby slopes. (Courtesy Danny Miller.)

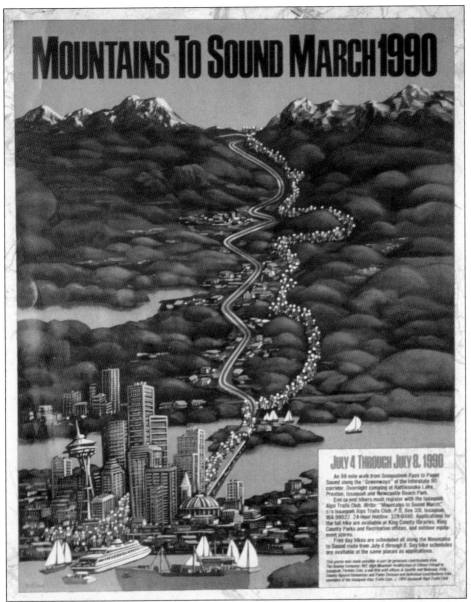

In 1990, a march organized by the Mountains to Sound Greenway Trust promoted a system of linked trails and scenic views along the Interstate 90 corridor in western Washington, as well as the protection of wildlife habitat. The march drew attention to the interstate highway as a potential threat to natural landscapes, in spite of its benefits. James Ellis, Brian Boyle, and Ted Thomsen were inspired to form the private nonprofit corporation. The trust's purpose was to prevent the heavily traveled corridor from becoming a strip city by creating a permanent "greenway" along 100 miles from the Puget Sound to the Kittitas County foothills. The strategy included supporting public purchase of private timberlands and separating corridor cities by green space wherever possible. In 2004, the Greenway Trust began holding the annual Greenway Days festival to promote awareness with a weekend of events along the Interstate 90 corridor. The main event is a 100-mile relay race that begins at Snoqualmie Pass and ends in Seattle. (Courtesy Mountains to Sound Greenway Trust.)

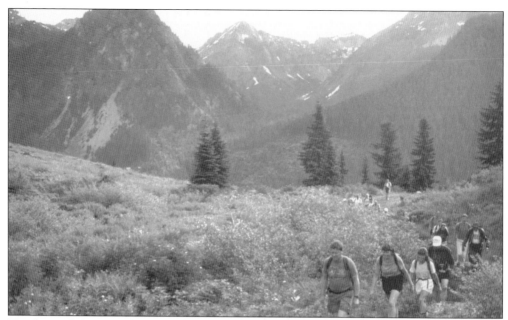

Nearly 100 hikers completed the 88-mile trek during the 1990 Mountains to Sound March, beginning on the Pacific Crest Trail near Snoqualmie Pass. In July heat, they walked along the dusty gravel bed of the abandoned Milwaukee Railway and continued hiking and camping overnight for five days until reaching the destination of Waterfront Park in Seattle. (Courtesy Mountains to Sound Greenway Trust.)

A fawn waits quietly for the return of its mother. Wildlife and forested mountain terrain are inarguably the greatest attractions Snoqualmie Pass has to offer. This gem of the Cascades can be preserved only if skiers, trail users, travelers, and residents take seriously the Bureau of Land Management's urgent message to "pack it in; pack it out" and leave no trace on the environment. Without public effort in the protection of forested areas, the habitats of wild animals and the beauty of many beloved areas, including Snoqualmie Pass, will become increasingly endangered. (Courtesy Danny Miller.)

BIBLIOGRAPHY

Cascade Times (formerly *Snoqualmie Pass Times*).

Chasan, Daniel Jack. *Mountains to Sound: The Creation of a Greenway across the Cascades*. Seattle: Sasquatch Books, 1993.

Kjeldsen, Jim. *The Mountaineers: A History*. Seattle: Mountaineers, 1998.

Lucas, Joy. *It Started in the Mountains: A History of Pacific Northwest Ski Instructors*. Seattle: Professional Ski Instructors of America–NW, 1995.

———. *The Ancient Skiers of the Pacific Northwest*. Self-published, 2006.

Prater, Yvonne C. *Snoqualmie Pass: From Indian Trail to Interstate*. Seattle: Mountaineers, 1981.

Seattle Post-Intelligencer.

Seattle Times.

Snoqualmie Pass Wagon Road. Washington, D.C.: Forest Service, U.S. Department of Agriculture, c. 1973.

Speidel, William C. Jr. *You Still Can't Eat Mt. Rainier!* Vashon, Washington: Nettle Creek Publishing, 1961.

Ware, Mary Jane. "He Remembers the Mountaineers in 1910." *Mountaineer*. October 1979: 6.

ACROSS AMERICA, PEOPLE ARE DISCOVERING SOMETHING WONDERFUL. THEIR HERITAGE.

Arcadia Publishing is the leading local history publisher in the United States. With more than 3,000 titles in print and hundreds of new titles released every year, Arcadia has extensive specialized experience chronicling the history of communities and celebrating America's hidden stories, bringing to life the people, places, and events from the past. To discover the history of other communities across the nation, please visit:

www.arcadiapublishing.com

Customized search tools allow you to find regional history books about the town where you grew up, the cities where your friends and family live, the town where your parents met, or even that retirement spot you've been dreaming about.